21 April – 11 June 1995

PRESS

Between Seduction
and Disbelief

ENTER

Chief Curator

Louise Dompierre

Adjunct Curators

Derrick de Kerckhove

Robert R. Riley

Curatorial Assistant

Jennifer Katell

The Power Plant—

Contemporary Art Gallery
at Harbourfront Centre

Canadian Cataloguing in Publication Data

Press/enter : between seduction and
disbelief

Essays to complement an exhibition of the
same title held at The Power Plant—
*Contemporary Art Gallery at Harbourfront
Centre*, Toronto, Apr. 21–June 11, 1995.
ISBN 0-921047-89-4

1. Installations (Art). 2. Technology in art.
3. Self in art. I. Dompierre, Louise.
II. Power Plant (Art gallery).

N6494.I56P74 1995 709'.04 C95-930829-6

COVER IMAGE
John Massey
Jack #35 1995

TABLE OF CONTENTS

DIRECTOR'S
FOREWORD

Steven Pozel

Press/Enter: Between Seduction and Disbelief is The Power Plant's most ambitious project to date. When Chief Curator Louise Dompierre presented the idea for this exhibition, we both recognized that it would require considerable research and partnerships with individuals, organizations, and businesses to realize. Neither of us imagined the challenges ahead, the scale and complexity of the undertaking. A sense of determination and the support and expertise of many people enabled *Press/Enter* to come to fruition.

Louise Dompierre's curiosity and thoroughness characterized her research for *Press/Enter*, which involved several years of studio visits with artists and others working in the field of advanced technology in Canada and abroad. I observed Louise's always considered and thoughtful approach as she dealt with the daunting scope of this project, considered the concepts that began to emerge, and distilled all the elements to create an exhibition that is both timely and predictive.

Press/Enter is also the result of teamwork by the dedicated staff of The Power Plant and those at Harbourfront Centre. Once again, I offer my sincere gratitude to them for their commitment and enthusiasm. This highly complex project was dependent on the skills and energies of many important people who worked quietly behind the scenes. In particular, I would like to thank

Jennifer Katell and Colin Griffiths, who were essential to the realization of this exhibition.

AT&T Canada readily lent its support to *Press/Enter* as the sponsor, and we are very grateful. Indeed, their commitment to this exhibition at its inception, well before artists were chosen or the concept of *Press/Enter* was fully defined, demonstrates the adventurous spirit of this company.

Last and most important, thanks to all the participating artists for creating such stimulating and challenging works. As part of *Press/Enter*, their contributions will generate much discussion and debate on how we perceive both the promise and the risk in these new technologies.

SPONSOR'S
FOREWORD

AT&T Canada

AT&T's association with the arts is rooted in our belief that the arts are an important form of communication – and, of course, communication is at the core of our business. Artists see the world differently, and they bring valuable insights and new perspectives to us all. They expand our vision, challenge our assumptions. They test limits and disturb conventions. Those qualities prevent cultural stagnation. They are essential to the creative process in the R&D laboratory and to the innovation in the marketplace.

In celebration of the communicative power of art, AT&T Canada is proud to sponsor *Press/Enter* as part of AT&T's arts program. This exhibition joins art and technology and by doing so reflects our longstanding support of new and innovative artistic work.

Helping museums to present and acquire the work of contemporary artists, especially Canadian artists, is of primary importance to AT&T's art program in Canada. Accordingly, AT&T is pleased to assist The Power Plant in presenting this important exhibition.

James J. Meenan
President and CEO
AT&T Canada

CURATORIAL ACKNOWLEDGEMENTS

Louise Dompierre

I wish to express my profound gratitude to the team of individuals who contributed to this exhibition. To begin with, I want to thank Derrick de Kerckhove, Director of the McLuhan Program in Culture and Technology at the University of Toronto, and Robert Riley, Curator of Media Arts at the San Francisco Museum of Modern Art, for the important role they played in the conceptual development of this show. Their knowledge of and familiarity with this field of activities proved crucial in the early stages of the project. Although the selection of the artists and the thematic structure of the exhibition were, in the end, my decision, their insights and suggestions inspired many of the choices made.

I would also like to acknowledge the invaluable assistance provided by Jennifer Katell, a curatorial intern from the University of Southern California. Jennifer's tireless efforts ensured not only that communications with the artists involved with this project were maintained throughout the preparatory stages, but she was also responsible for the meticulous collating of all the data required for the development and realization of the exhibition and accompanying publication. Her many ideas and suggestions challenged me in a most productive way, and for this I am immensely grateful.

The support of AT&T Canada came about at an important moment. AT&T's understanding that a commitment was needed

early assured that the exhibition would take place. I am especially indebted to Timothy J. McClimon, then Vice-President of the AT&T Foundation, to Suzanne Berman, and more recently, to Jim Wentzell for their confidence. Other funding agencies and partners also played a significant role in enabling us to realize this project. In particular, I wish to acknowledge the generous support of the Canada Council; the Goethe-Institut Toronto, notably Wilfried Scheffler and, as always, Doina Popescu; and Frédéric Limarre, Attaché Culturel et Scientifique, Consulat General de France, Toronto.

Research for this project also involved meeting a number of persons whose long-term commitment to this field is well known. These include Kazunao Abe and Yukiko Shikata (ARTLAB, Tokyo), Martine Bour (Délégation aux Arts Plastiques, Ministère de la Culture et de la Francophonie, France), Alain Fleischer (Directeur, Studio national des Arts Contemporains, Tourcoing, France), Monika Fleischmann (Gesellschaft für Mathematik und Datenverarbeitung MBH, Sankt Augustin, Germany), Claude Fort (Ars technica, La Villette, France), Heide Hagebolling (Kunsthochschule für Medien, Cologne, Germany), Alain Reinaudo (Director, Centre d'Art d'Herblay, France), Georges Rey (Commissaire de la Biennale d'Art Contemporain de Lyon, 1995), Marie-Paule Serre (Ministère des Affaires Étrangères, Association Française d'Action Artistique, Paris, France), Jeffrey Shaw (ZKM/Institut für Bildmedien, Karlsruhe, Germany), Peter Weibel and his colleagues (Städelschule – Institut für Neue Medien, Frankfurt, Germany), as well as many artists whose studios were opened to me during the long research phase for this project. All contributed in some way to the exhibition as it now stands.

As always, The Power Plant team surpassed itself: Paul Zingrone took in his stride the many complications that the installation of the work required; Norah Farrell tirelessly sought equipment; Karmen Steigenga ensured, with her usual sense of humour, that we all kept to schedule; Teresa Casas expanded on the ideas behind this exhibition with her complementary programming; Steven Pozel, our Director, was endlessly supportive, despite the many challenges that the project presented; and all the other staff members, at one level or another, helped realize this exhibition. I am grateful to our extended team, including Jillian Peters, Adams + Associates (design), and Alison Reid (editorial), for the care and the commitment they gave to the publication, in spite of the impossible deadlines that they were once again presented with.

Finally, thank you to the authors, whose insights are the substance of the book, and to those Toronto artists in the exhibition, such as Sylvie Bélanger and David Rokeby, who so generously shared with me their familiarity with the subject and whose thoughts certainly influenced the nature of this project. Thanks, too, to John Massey, who gave me permission to use his latest work on the cover.

INTRODUCTION: ON HOLD - BETWEEN SEDUCTION AND DISBELIEF

Louise Dompierre

Both life enhancing and a source of inspiration for the popular imagination, cybernetics has reached into almost every aspect of everyday life: from the home to the office, from the desk of the scholar to that of the journalist, few activities have not been affected to some degree. Yet much apprehension, even anxiety, about this field remains. Given that both the terminology and the concepts are new and sometimes difficult, and that it tends to raise as many questions as it appears to answer, cybernetics has yet to gain general acceptance. Both personally and as a curator, I find myself ambivalent about the subject – attracted to the advantages that technology offers and wary of the consequences of some of the changes it fosters. Much of contemporary art is involved with these issues.

We live in a time when machines can be made to engage in dialogue with us and between themselves, when virtual sex is realizable, and when we can, with our own breath, displace an image on the screen. Can we then "close our eyes," turn our backs and say no to a "Soft Future"?[1] Certainly the complexity and the implications of the relationship that we and our bodies experience with late-twentieth-century technology cannot be simply dismissed or accepted as inevitable.[2]

Some years ago, while working at my computer desk, I came to the realization that my thoughts had gradually shifted from

what I was writing to the machine that sat in front of me. Looking at it, occupying a privileged place in my study, I wondered, as I often have since, about the impact of this new technological tool in my life. My concern, I should say, was less about the possibility that this megamachine might be "disciplining and punishing" my body than about the conditioning process that I felt was occurring.[3]

Soon, my passing reflection on how computers might affect the way I thought drifted to other technological tools, from bank machines to electronic phone-answering devices, that had also entered my life. As Alice Jardine points out, "One way of becoming a machine is to hook yourself up to one: video games, media, television, the new non-umbilical telephones (that transmit through walls), etc. This technology is described by some as an external nervous system connected to us by a variety of devices that radically change our sense of time and space."[4] To this consideration of the new and profoundly affecting notion of space that computers create, N. Katherine Hayles adds: "The contraction of external space did not in fact signal the end of spatiality, but rather its reconstitution on the other side of the computer screen and in the dark interior of the body."[5] Within this context, the next or final step becomes obvious: to "look like" or even to become a machine, torn as we are between the world as we know it and the uncharted territory of cyberspace.[6]

Technology, of course, is not new. What is new, perhaps, is the extent to which technology has come to control our lives in the late twentieth century.

When I initiated this project, I had little idea what I would discover with an exhibition like *Press/Enter*. I do not refer to its practical demands – they are clearly numerous. I wish, rather, to emphasize the complexities that already exist in this quickly

expanding field. Much debate, of course, is taking place in the mass media and in scholarly publications about recently developed technology. Studies on technology with applications to medicine, space research, labour, economics, warfare, robotics, and telecommunications abound.[7] Still under inquiry are the philosophical parameters of the debates about technology. In other words, not only is it a challenge to determine how and when to engage with technology, but it is also unclear whether the nature of the debate is worthwhile or productive: are the questions we are asking about technology the right ones?

Should these questions, as Wolfgang Schirmacher suggests, concern the difference between the world as we know it and the world of cyberspace? As he notes, "Today's reality points to an immense shift: the emergence of artificial life as the reality for human beings."[8] Or, should we, as Hayles suggests, explore the reasons behind the drive to transform human existence, to "improve it" through technological advances. As she explains, current research in robotics, cryogenics, genetic engineering, and nanotechnology is a search for "complete omnipotence: the power to remake humanity, earth, the universe at large. If you're tired of the ills of the flesh, then *get rid of the flesh*; we can *do* that now." She adds, "The point is not merely to leave the body but to reconstitute it as a technical object under human control. The essential transformation is from biomorphism to technomorphism."[9]

Shirmacher and Hayles certainly raise interesting issues about cyberspace, one being rooted in the difference between the world as it is now and the world as we knew it merely decades ago, and the other in the economy of power and the perennial dream of world hegemony. To my mind, however, only those who, like Michael Heim, question "why we invent virtual worlds" actually go

to the crux of the matter, examining how "the metaphysical laboratory" (i.e., cyberspace) fits into "human inquiry as a whole."[10] Making connections to precedents in philosophy from Plato to Leibniz, Heim insists that "the computer's allure is more than utilitarian or aesthetic; it is erotic." He emphasizes that "our affair with information machines announces a symbiotic relationship and ultimately a mental marriage to technology. Rightly perceived, the atmosphere of cyberspace carries the scent that once surrounded Wisdom. The world rendered as pure information not only fascinates our eyes and minds, it captures our hearts. We feel augmented and empowered. Our hearts beat in the machines. This is Eros."[11] *Seductive* as cyberspace may be, it is also replete with paradox.[12] Hence, perhaps, our *disbelief* in the world of simulation it offers.

Press/Enter has been structured within the field of speculation posed by Heim. Starting from the position that the engagement of the human subject with the machine is in large part emotional, even erotic, it explores the dialectic of seduction and disbelief that contemporary art generates around issues of human identity and cyberspace. At the same time, while engaging – in however modest a manner – with the intellectual debate relating to works informed by new technology, *Press/Enter* also acknowledges the ambivalence that characterizes the discourse on technology. In fact, it could be said that this ambivalence is one of the fundamental principles underlying the exhibition. Despite the many insights of writers on technology – including, I should stress, those of Hayles and Shirmacher – there remains a sense that much of what is being said does not begin to address essential questions about technology.

A number of characteristics are quickly emerging in contemporary artworks that address issues of technology. For example, although many works in this exhibition remain traditional in the sense that their material existence reassures us that they can be engaged with as art, others, such as those alluded to above, are formless digital manifestations. As Richard Wright has recently indicated, "Digital technology has no form – look at your computers, they are all the same. They have no mechanical parts, they are just boxes of tiny silicon cubes. They are becoming smaller, they are becoming invisible. Soon they will disappear from the real world altogether and will exist only through the images they project. This technology does not act, it evokes. It can implant the images of hidden desires in our brains, there to grow and germinate."[13] For centuries now, the idea of being able to own objects that could be contemplated over time has conditioned our thinking about art. Can we now live with art that manifests itself only momentarily? Or art that depends on constantly evolving technology, the pace of its development faster than attendant artistic possibilities can be probed by artists? Can we accept this as art? Can we leave aside the "miracles" of popular culture, including those of cinema and computer games to engage with works not having the notion of "spectacularity" as central? And what about the future of museums when art objects in the strict sense of the term no longer exist and/or require such technical expertise to display that few institutions dare collect them?

Certainly, works such as those in this exhibition tend to intrude into and transform our customary engagement with the art object. No longer serving only to *represent*, art here becomes actuality as it is more or less performed in the space. The works consist of a variable element, which is the viewer's image. This

serves as a reminder that the process of looking at art can never be dissociated from the observer, and also emphasizes ambiguity, a grey zone where the shrinking distinction between human beings and machines is enacted. In this space, and at this level, we have come to serve the purpose of the machine.

Edmond Couchot's poetic *Je sème à tout vent (plume* et *pissenlit)*, which exists only for the duration of a human breath, is perhaps one of the most striking examples of this in the exhibition. As a box of silicon cubes or as a projected image on the wall, the work, to use Richard Wright's terminology, has no form. *Je sème à tout vent*, like other works in *Press/Enter*, involves a process that goes far beyond mere formal characteristics. "Breaking the barrier of the screen," this work puts us in direct contact with an image and with the immaterial.[14]

Out of this passage into the screen not only does *Je sème à tout vent* acquire new meaning, but it also represents the first transformative state we undergo in our march towards becoming, perhaps, "less human." As Donna Haraway, the most quoted author on issues of technology, argues, "Machines are disturbingly lively" and "we ourselves [are] frighteningly inert."[15] This is the sense that emerges when we consider *Family Portrait: Encounter with a Virtual Society* by the Montreal artist Luc Courchesne. This work engages us in a dialogue with its virtual beings, who evidently determine when they wish to ignore us and when, unless we happen to feed the machine the right answers, our engagement with them will end. A similar sense of helplessness also conditions our interaction with such works as *The Silence of the Body* by Sylvie Bélanger, Jim Campbell's *Untitled (for Heisenberg)*, and Christian Möller's *Electronic Mirror*.

Furthermore, the idea of "leaving the body," as Hayles says, and being made visible in virtual space is a process apparent in most of the works included here. In contrast to, say, the bodies in video games that are constituted by descriptive codes that "embody" expectations of appearance, the bodies reconstituted in cyberspace throughout the exhibition are our own.[16] Works like those by Jim Campbell, Catherine Ikam, Christian Möller, and George Bures Miller all operate within this idea, fracturing the self in two, simultaneously turning us into viewers of our own selves. Furthermore, through this process not only are new boundaries crossed but the body is reconstituted as a "technical object."[17] In brief, says Alluquère Rosanne Stone, "The boundaries between the subject, if not the body, and the 'rest of the world' are undergoing a radical refiguration brought about in part through the mediation of technology."[18]

Entering the screen, Stone says, "involves a state change from the physical, biological space of the embodied viewer to the symbolic, metaphorical 'consensual hallucination' of cyberspace."[19] She notes that "cyberspace both *dis*embodies ... but also *re*embodies in the polychrome, hypersurface ... of the console."[20] Cyberspace reconfigures consciousness, but "consciousness remains firmly rooted in the physical."[21]

This new cybernetic construct consisting of body-plus-equipment-plus-computer-plus-simulation that displaces the "natural" body also generates a profound incompatibility, a "confusion of boundaries," about this encounter of inert matter and the living self.[22] This new hybrid entity aptly embodies, I believe, our sense of being in the late twentieth century. From this moment of encounter not only are we under surveillance but, most important perhaps, we automatically pass into a mode of "self-surveillance."[23] Artists are

strongly aware of this, particularly Julia Scher, whose work centres on issues of surveillance. But others, like Campbell, Ikam, Bélanger, Fleischmann, Möller, Miller, and Spinhoven use surveillance as an integral strategy. Without it, these works would not exist.

This transformation process we are undergoing, though well understood by artists, also wreaks havoc at a theoretical and critical level. According to Stone, "Many of the usual analytical categories have become unreliable for making the useful distinctions between the biological and the technological, the natural and artificial [or the organic and the synthetic], the human and mechanical [or originals and copies], the social and the technological to which we have become accustomed."[24] This deconstruction of modern thought also leads to the disappearance of "the bottom-line binary of traditional ethics: life and death," notes Jardine.[25] Furthermore, as Stone argues, "These new spaces instantiate the collapse of the boundaries that are part of the postmodern imaginary."[26]

Or, as Hayles suggests, "By denaturalizing assumptions about physicality and embodiment, cybernetic technologies also contribute to liberatory projects that seek to bring traditional dichotomies and hierarchies into question."[27] Ungoverned by rules as we know them, cybernetics opens itself to new contemporaneous constructs and questions some of the tenets that have previously inspired and guided critical analysis. What will these new constructs be? What role will art play in their articulation? "Pools of Reflection" offers one perspective on the issues currently being considered by contemporary artists. Other observations on these issues are provided by Derrick de Kerckhove and Robert Riley in their essays. Riley focuses on questions of "Figuration and Intimacy in the Electronic Media," and de Kerckhove discusses a "new variety of mind" that is technically assisted, collective, public, and dynamic.

These two authors also offer a contextual and historical perspective on the development of electronically based art. For his part, Michael Heim emphasizes art's role in lifting "a mirror to show the power and peril of nascent technologies." He notes the implicit hazard in what he calls Alternate World Syndrome (AWS), "an acute form of body amnesia." "Making us prone to errors in mismatched contexts, AWS mixes images and expectations from an alternate world so as to distort our perceptions of the current world." Finally, Allucquère Rosanne Stone proposes new possibilities for the post-mechanical body and its "multidimensional tactile extensionality."

Among the many issues that are discussed, some are profoundly ethical, if not moral, in nature. Do we wish to be party to this transformative process, and also, perhaps more significantly, how will we relate to the absence or relative absence of control mechanisms in this new world? This returns us where we began: what is this will that is transforming our present and our future?

This is the underlying consideration and one of the subtexts of *Press/Enter*.

Notes

1. I am making reference here to three works. These are, in the order given above, *Family Portrait: Encounter with a Virtual Society* (1993) by the Canadian artist Luc Courchesne; *Telematic Vision* (1993) by the Welsh artist Paul Sermon; *Je sème à tout vent (plume et pissenlit)* (1988, 1992) by the French artist Edmond Couchot. "Soft Future" is a well-known term. I was reminded of it in Richard Wright's article "Soft Future," *Variant* 14, Summer 1993.

2. Donna Haraway, "A Cyborg Manifesto: Science, Technology, and Socialist-Feminism in the Late Twentieth Century" in *Simians, Cyborgs, and Women: The Reinvention of Nature* (New York: Routledge, Chapman and Hall, 1991), 181.

3. Alice Jardine, "Of Bodies and Technologies," in *Discussions in Contemporary Culture*, ed. Hal Foster (Seattle: Bay Press, 1987), 152.

4. Jardine, 155.

5. N. Katherine Hayles, "The Seductions of Cyberspace" in *Rethinking Technologies*, ed. Verena Andermatt Conley on behalf of the Miami Theory Collective (Minneapolis: University of Minnesota Press, 1993), 185.

6. Hayles, 155.

7. Hayles, 154.

8. Wolfgang Shirmacher, "Homo Generator: Media and Postmodern Technology" in *Culture on the Brink: Ideologies of Technology*, ed. Gretchen Bender and Timothy Druckrey (Seattle: Bay Press, 1994), 66.

9. Hayles, 173.

10. Michael Heim, "The Erotic Ontology of Cyberspace" in *Cyberspace: First Steps*, ed. Michael Benedikt (Cambridge, Mass.: The MIT Press, 1991), 60.

11. Heim, 61.

12. Heim, 73.

13. Wright, 7. This issue of *Variant* was also the official catalogue of *Video Positive 93*, Britain's biennial international festival of creative video and electronic media art.

14. Hayles, 174.

15. Haraway, 152. This idea can also be traced back to Marshall McLuhan. Heather Menzies recently pointed out, "As Marshall McLuhan phrased it back in the 1960s, the emerging webwork of information networks is becoming our new 'environment,' our 'surround.' The machine no longer exists outside us; that's industrial age thinking. We live in the machine: in the largely invisible webwork of wires and other linkages integrating and controlling all the information devices that

are visible in front of us. This enveloping machine structures our choices and, in doing so, structures our lives and our consciousness through the assumptions built into its software." Heather Menzies, "Hyping the Highway: Is the Information Highway the road to a common future or just another trip to the mall?" *The Canadian Forum* LXXIII, no. 830 (June 1994): 24.

16. Allucquère Rosanne Stone, "Will the Real Body Please Stand Up?: Boundary Stories about Virtual Culture" in *Cyberspace: First Steps*, ed. Michael Benedikt (Cambridge, Mass.: The MIT Press, 1991), 103.

17. Hayles, 173.

18. Stone, 101.

19. Stone, 109.

20. Stone, 109.

21. Stone, 111.

22. Hayles, 174, and Haraway, 150.

23. Bob Somol quoted in Jardine, 155.

24. Stone, 101.

25. Jardine, 157.

26. Stone, 85.

27. See Hayles, 174–75.

POOLS OF REFLECTION

Louise Dompierre

Terminal Identity

I feel like an intruder as I enter Jim Campbell's *Untitled (for Heisenberg)* (1994–95). Lying side by side on a bed in front of me are a man and a woman. They are nude. Alone in the long and narrow space, I find it impossible to look away from their image.

The bodies move slowly, almost ponderously, as if in a slow-motion film. Filled with curiosity, I approach closer. As I do, another image appears on the grainy surface. To my surprise, I realize that this image is mine. Theirs has melted into the background.

The more I observe the couple and move around the room, the more visual variations emerge. I can hear soft whispers.

As I stand transfixed, John Massey's *Bridge at Remagen* (1985) comes to mind. The work hangs on the wall at the entrance to this space. Like Campbell's *Untitled (for Heisenberg)*, Massey's work represents a couple embracing.

The process of identifying with a person in an image, whether still or moving, and conceptually entering the space of represen-tation is well known and used by both artists and filmmakers. Driven by desire or by some comparable emotion, we easily imag-ine ourselves present in the space created for us, seeing ourselves in the role of protagonist. Massey's *Bridge at Remagen* subtly cap-tures this idea by showing two powerful hands, obviously on a different plane of representation from the image they hold, tak-

ing possession of and seemingly entering the surface of the represented object. In contrast to this conceptual reenactment of desire, Jim Campbell's work transposes the viewer's body – that is, an image of the person – into the space of representation.

As Allucquère Rosanne Stone points out, "It is the potential for interaction that is one of the things that distinguishes the computer from the cinematic mode, and that transforms the small, low-resolution, and frequently monochromatic electronic screen from a novelty to a powerfully gripping force. Interaction is the physical concretization of a desire to escape the flatness and merge into the created system."[1]

Using principles different from those of cinema, cyberspace "thickens" the present, producing a space that is deep and textural, one that, according to Vivian Sobchack, can be materially inhabited.[2]

Campbell's work is a good example. It simultaneously offers the opportunity of entering the space and speculating about our presence there. With *Untitled (for Heisenberg)*, the usual physical boundaries between ourselves and the object of representation are expanded, allowing us to experience the work from within as well as from outside.

Although the "violation or dissolution of body boundaries" is, as Bruce Clarke notes, inherently erotic, the act of passage itself is, according to Scott Bukatman, known as "terminal identity."[3] He says, "[In this] articulation ... we find both the end of the subject and a new subjectivity constructed at the computer station or television screen.... The simultaneous estrangement of the self from itself and its reconstitution as Other suggests that the diffusion of subjectivity through the cybernetic circuit constitutes a second mirror stage, the Mirror of the Cyborg."[4]

From Jacques Lacan we learned that "the first mirror stage marks the initiation of the subject into language, the realm of the

symbolic, and into the deferral and continuing lack that consti-tutes the play of signifiers."[5] The dialectic of absence and pres-ence is central to Lacan's theory. The second mirror stage assumes that "the speciousness of presence has been demonstrated and moves beyond it."[6] Its central dialectic is randomness and pattern. N. Katherine Hayles elaborates: "Constructing the subject through the flow of information that circulates within and around the sys-tem, it marks objects through patterns of assembly and disassem-bly rather than through the physical boundaries that are specular-ly recognized in the Lacanian mirror. Language gives way to the more general concept of messages-in-the-circuit. Communication takes place not only through words and syntax but also through the manipulation of cyberspace parameters."[7]

In other words, in the second mirror stage, the "Mirror of the Cyborg," anxiety about identity, or alternatively, reassurance about who we are, is not dependent on the notion of absence and presence but "on informational patterns that must cohere for continuity of the subject to be assured."[8]

This concept is integral to Jim Campbell's *Digital Watch* (1991). The work uses a clock that registers the visitors in virtual space and controls them to the extent that the movement of the arms of the clock represents them in a state of stillness or motion. At the same time, the surface around the clock functions as an actual mirror. These two reflexive registries enable a process whereby, on the one hand, subjectivity is reconstituted in cyberspace and, on the other, whereby subjectivity is made to hover between the Lacanian mirror stage and a state of terminal identity. At this level, subjec-tivity is on hold, being made to exist in transit between the two states. Through the back-and-forth process, the work subjects iden-tity to a state of anxiety, preventing informational patterns from

cohering. By inscribing our presence in cyberspace, the work directs a passage between a condition that could be described as that of "listener and speaker to [one where one becomes] actor-spectator."[9]

Campbell's work is the entrance point to the exhibition, marking our journey, as we progress from work to work, from the world as we know it to one where subjectivity is either reconstituted or challenged in virtual reality. Certainly embodying the theme of the show, *Digital Watch* also symbolically indicates a new time and place, spatially extending our perception and our presence into uncharted territory.

Other works in the exhibition, such as Christian Möller's *Electronic Mirror* (1993), also rely on the mirror as a device to signify our entrance into cyberspace. Unlike Campbell, who positions the two types of mirrors side by side, Möller combines the mirror states in one. In *Electronic Mirror*, he explores the sense of loss and the disorientation that may be experienced in cyberspace because we are not in control there. By means of an altered and computer-controlled mirror and an ultrasonic sensor, the work measures the viewer's distance from it. When a viewer enters the mirror's "live" field, a more or less distinct image of herself or himself is captured on its surface, depending on the viewer's position in relation to the object. At this level, the work reenacts the experience with an actual mirror. However, at a certain distance, even though the viewer might still be standing in front of the mirror, the image disappears. Unlike an actual mirror, which will record our image no matter how far away we stand from it, as long as we remain within its field of reflection, Möller's mirror controls the presence or absence of our image on its surface. At a certain point the work blanks us out, denying our existence. This strategy, however phenomenologically driven it might appear,

profoundly unsettles our sense of being, probing our deepest fears. There is the fear of having no control over the vastness of cyberspace and apprehension about our own disappearance from the world. Physical absence from the world means death, unless we believe in invisibility. Absence in cyberspace emphasizes the possibility of experiencing invisibility, however troubling this may be and however much it may stress our lack of control over the mechanisms of computer space.

Möller's mirror is not only an artwork but it can also be integrated into the actual architecture of a home environment. He is an architect whose aim is to dematerialize static architecture. Inspired by the school of thought that developed from Hans Hollein's 1968 manifesto urging architects to stop thinking of architecture in traditional terms, Möller sees architecture as a living and dynamic system that opens the possibility of a visual discourse between it and its inhabitants.

Such an *Electronic Mirror* in a home expands, however temperamentally, the functions of a mirror and places our image – that is, our surrogate self – in a live environment. As such, it profoundly transforms the dynamic between architecture and its users from passive to (inter)active. We may speculate on how deeply this would affect our sense of being in the world. Furthermore, as discussed earlier, this process does not "mark the end of spatiality" but reconstitutes it on the other side of the computer screen or, in this case, extends our sense of architectural space into an infinite and unstructured territory. In a sense, this opens up a potentially ever-evolving environment where nothing is finite and stable.[10]

Monika Fleischmann appears to return a certain semblance of control over our presence in cyberspace. Her installation, *Liquid Views* (1993), duplicates the effect of gently rippling water and

simultaneously captures the viewer's image. As with water, if the viewer disturbs the surface of the work, his or her "reflection" dissolves. Although the work simply appears to mimic the reflective property of a liquid surface, what really occurs is that the image of the viewer has been stored digitally and altered within the computer. The illusion gives the viewer a sense of control; in actual fact, the machine manages the experience. Fleischmann thus forces us to consider the act of looking. She also invokes the fear that science fiction has often explored: the obscure and unpredictable process whereby wires cross and computers take on a "life" of their own, while reassuring us that we still hold control over them.

David Rokeby's *Silicon Remembers Carbon* (1993–95) could be said to reverse the above process, arising as it does from the artist's own scepticism about cybernetics and in particular interactive technologies. Relying on our desire to figuratively project ourselves into an image and on the construct of becoming a cyborg, Rokeby's strategy ironically defies all expectations.

Like Campbell, Rokeby engages the viewer's imagination by first establishing the scene. As we enter the room, darkness is total. After a brief struggle to find our way into the space, we see on the floor an image on a bed of sand surrounded by a narrow walkway. When we stand motionless on the walkway, everything is still. But as we venture into the space of representation, images start flowing into one another. Soon we become aware of shadows and footprints that we have left behind in the sand. Or are these our shadows and tracks?

Perhaps conditioned by prior experiences such as Jim Campbell's work, we tend to believe, initially at least, that they are ours. Certainly the tracks in the sand are definitive proof of our presence; however, the shadows and reflections are more

problematic. Knowing that visitors will believe that these too are their own, Rokeby surprises, altering the expected experience by including preprogrammed shadows and images. If and when that realization dawns on us, not only do we feel excluded from the system but we also find ourselves encumbered by an alien "other." To a large degree, this is what being a cyborg means: although interactive devices provide the opportunity to see ourselves "out there," at the same time we know that whoever we see out there is not quite the same as the person who stands here, however much the illusion insists that it is. A cyborg is, in a way, a synthesis of human and machine. Here, Rokeby plays with the idea of being a cyborg, but his denying us entry allows us to remain, so to speak, human.

From Human to Cyborg

The works discussed above focus on the erotic nature of our passage into cyberspace and the process of transformation that the human subject's sense of identity undergoes during that passage. In contrast, others by Christine Davis, John Massey, Catherine Ikam, and Sylvie Bélanger draw our attention to biologically constituted beings in a process of change. Both groups of works, however – despite the fact that Bélanger, Davis, Ikam, and Massey rely on such means as fragmentation, absence, and reconstituted presence to do so – emphasize a deeply altered sense of the self. Both can be said to speak to our new status as cyborgs or, at the very least, to the process of our so becoming.

In 1980, Catherine Ikam began working on destructuring the face with *Identité III*. This work uses the fragmentation or, as Nam June Paik called it, decomposition, that the video medium

makes possible.[11] In Ikam's installation, a single chair faces a series of small monitors. As we sit on the chair, surveillance cameras pick up our image and transmit it, fragmented and at times distorted, to the various monitors facing us. The effect is both riveting and unsettling as we attempt to reconstruct our face with the fragments. Images look back at us, like reflections in the pieces of a broken mirror, without really being us. Not once can we see ourselves as other than an explosion of parts, nor can we hold these parts together in a single image.

Unlike a mirror, which validates us, this work effects the disappearance of the self as we know it. Its framing mechanisms – the separate monitors – dis-integrate the face. And the process brings out characteristics that either do not exist (distortion) or that might otherwise go unnoticed, such as tiny age lines near the eyes, a pimple on the chin, a bulbous forehead, or other details. The compelling images represent ourselves yet offer a markedly different view from the one we usually see in a mirror. According to Nam June Paik, "The sum total of all the parts does not equal to the whole, unless you know the secret code."[12] In her pioneering work, Ikam recognized early the possibility that "human perception is itself a mechanism which accepts its pixelled vision as reality."[13] This piece emphasizes that we do not see ourselves, that we can never see ourselves, no matter how long we remain in the chair, and that even if we were to, the self we see is unlike what we have known ourselves to be. It also underlines that a video image, like a photograph or a still image of any kind, is mediated, however immediate and "true" the reproduction appears to be.

Drawing from the postmodernist understanding that we both constitute and are constituted by language, Christine Davis, like Ikam, also investigates the idea that human perception is condi-

tioned by technology. With *Le dictionnaire des inquisiteurs (tombeau)* (1994–95), Davis focuses on the connection among human vision, perception, history, and language. To develop this idea, she relies on an absent physical presence, substituting instead prostheses, artificial body parts. Her installation consists of a small room with a long narrow light box set into the wall facing us as we enter the room. A series of contact lenses – actual discarded ones – with words laser-etched on their surfaces are placed on a sandblasted glass shelf at the bottom of the light box. The room is in semi-darkness, leaving only the rainbow-coloured lenses, two striking red ones among them, illuminated by a row of low-voltage lights from below.

Contact lenses are an interesting example of how science and technology can unobtrusively transform and protect vision. The body soon adapts to them, and they provide clearer and sharper eyesight. Simultaneously drawing attention to sight and to the biological body by means of its absence, this work also calls for a consideration of how technology can, often inconspicuously, change our perception of the world and ourselves. The mausoleum-like quality of the space draws attention to the ambivalence we feel towards the objects under consideration. Although they may enhance some lives, contact lenses also imply the inability of the biological self to perform without corrective devices and increasingly without technological assistance.

Etched on the surface of the lenses, which are in rows of pairs inside the light box, are words drawn from *Le dictionnaire des inquisiteurs*, a book published in Valencia in 1494 for use during the Spanish Inquisition. Listed in alphabetical order, the words are coincidentally juxtaposed in ways that are by turn apt, inspiring, odd, and intriguing, such as *absolution/accusation, blasphéma-*

teur/bon, chance/chasteté, enseigner/erreur, mariage/masculin, sen-tence/sentir, or even *spontanément/superstition.* Originally meant to judge manifestations of heresy, the words are here given new meaning resulting from their paired arrangement and their trans-formation from items of everyday use into art objects. Thus recon-figured, language and history, truth and jurisprudence take on levels of meaning totally unanticipated by those who developed the dictionary. Both within and outside that earlier phase of human history, they exist now as new truths. By inscribing these words (language) on the lenses by means of a laser process (two techno-logical procedures), Davis metaphorically returns to or (re)places these new truths in the body, where they invisibly transform iden-tity. This process can also be related to the manner in which cyber-netics reconstitutes subjectivity, and the way prostheses of all kinds (re)condition the body.

John Massey's *Jack Photographs* (1992–95), a series of computer-assisted black-and-white photographs, address the idea of a reconsti-tuted self, half-human, half-"robotic." The images, partly a photo-graph of the artist himself and partly a "drawing Adam," focus on the human subject as a biological/mechanical construct and on the inner forces, such as desire, that drive him.

The two-dimensional work, which consists of thirty-five images, humorously depicts some basic experiences of a person: Jack awakes, Jack stands, Jack is startled, Jack feels, and so on. Using discrete images, like the individual frames of a film – although here the images are circular and of varying diameters, suggestive of male desire – the work takes us through an almost step-by-step story in which the biological/mechanical body experi-ences various states of being while all the other senses gradually accede to the dominance of sight. Zooming in on a single dark

hole, the series evolves towards a paroxysm of darkness. Through this process the eye becomes not only the locus of human desire but also a dark and deep space, having lost some definition as an eye. Furthermore, the caption at the bottom of the image, "Jack looks ahead," associates one of the later frames with the notion of the future.

At one level, the work reveals issues of morality that one encounters as part of the daily routine, including those resulting from desire. At another level, the work draws attention to the risk that cybernetics itself poses to humankind at this point in time: by refering to the future ("Jack looks ahead"), to a body (part human, part machine), and to the idea of deep space, like cyberspace (the hole), the work posits a state of being in which the body, no longer primarily biologically constituted, functions increasingly within the dark matrix of cyberspace. Jack is not yet in. The question that faces him and us is whether to take the plunge and experience the ultimate erotic union.

Additionally, the hole/eye itself contains the infinite space of the future. Seductive yet daunting, it both attracts and frightens. Standing on its edge, one may be tempted to explore its rich black texture. At the same time, who knows what fate the body will be subjected to, once inside? The hole, like cyberspace, has become a womb ready to give (re)birth.

The Silence of the Body (1994) by Sylvie Bélanger is a work in three movements, each performed at a specific moment.[14] Distinct yet related, these moments offer a fragmented, inert, and objectified human body. *The Silence of the Body* involves phasing out the boundaries between the self, the object, and the immaterial, like the concept of terminal identity already mentioned. The work also addresses surveillance, human complicity (and narcissistic pleasure), and

the much-discussed cyberfeminist notion that "cyberspace certainly tempts its users with the ultimate fulfillment of the patriarchal dream, leaving the proper body behind and floating in the immaterial."[15]

Reconstituted and taken together, the three major elements, the eyes, ear, and mouth, suggest a face. However, a face they are not. Separate, disembodied, each element is simultaneously transitional and a zone of reflection in itself; each also demands its own discursive space.

To See: Of these individual fractured parts, "the eyes stand like a colonnade at the entrance of the room. In the section where the pupil of the eye should logically appear is a glass surface with the word *voir* [to see] etched on its surface. Beyond the glass are inserted video monitors in which spectators can see their own image, in colour video, returning the gaze."[16]

Here, *The Silence of the Body* involves a transformative process that occurs at the moment of our passage into and out of the eyes' pupils, as we walk through this work. But the point of encounter between our mediated self and another mediated surface is where the work begins: once we walk through, once we accept leaving the image of the self behind, we metaphorically enter a cybernetic environment.

For a moment, or for however long we choose to gaze at our image in the eyes, we are in a "doubly" mediated field. The eyes not only embody our reflection, they are us. Cyborg or android, the eyes are being fed our identity.[17] Yet the momentary and narcissistic pleasure of discovering our image behind the word *voir* is soon displaced by other considerations. As Donna Haraway notes, "By the late twentieth century, our time, a mythic time, we are all chimeras, theorized and fabricated hybrids of machine and organism; in short, we are cyborgs."[18]

This work also acknowledges the increasingly blurred lines of gender identity. The eyes, which can be seen as feminine – but were they masculine and the viewer female, the effect would be equally true – become the recipients (of the gaze and of the viewer's image) for viewers of either sex. Moreover, as the work consists of two elements (that is, two eyes), we find ourselves simultaneously projected (metaphorically cloned) in both pupils. Science fiction has, of course, familiarized us with the idea of the duplicated self, but in an era of rapid development in bioengineering, self-duplication has become a real possibility, not just an idea. Such a notion certainly raises a number of ethical issues in relation to human life and the processes by which life is generated and individual identity preserved.

This realization brings us to one of the most disturbing aspects of the work. We recognize our image at the same time that seeing it distinctly is almost impossible because it appears behind glass and the etched word *voir*. Twice removed from us, our image is hidden behind the infinitive urging us to see. Can we really see ourselves? Or what do we see? We think that the projected image is ours, but can it really be? Mediated, we are no longer as we stand in the room. Yet, as in Ikam's *Identité III*, we want to believe that we are unchanged and that the image that we see is what and who we are. Bélanger's work not only alludes to the gradual transformation of the human body through advanced technologies but also ironically reminds us of our own resistance, maybe even our inability, "to see" this process occurring.

To Emit: As we advance in the exhibition space, we come upon the mouth, the second element of the work. It is placed in the centre of the room and is at the core of the work. "Here the spectator looks down on the back-lit details of the mouth. The

word *émettre* [to emit, utter, or transmit] spills out across the floor in the centre of the mouth. *Émettre* is spelled out one letter at a time: then, with increasing speed, starting from a small point and evolving into large letters, begins to form a spiraling vortex of jumbled letters."[19]

No matter when or how we come across this second element, it is initially difficult to make sense of what it is we are asked to notice. Even when the word reveals itself, we are not sure of its significance. *Émettre* refers to a process by which something is spilled out. Having metaphorically entered, as we have, cybernetic space, we may consider this element to mean that our new cybernetic identity is being programmed. Here, in this space, we are no longer reminded of who we are. Representation, as symbolized by the mouth, has become fragmented, no longer embodying the self. Even what is being transmitted does not really matter. The emphasis is on programming or on the act of transmitting information.

For a moment, Bélanger wants us to lose ourselves in the power of the image and experience it fully. Such a process recalls the dizzying effects of virtual images and spaces on the human mind/eyes.

As Richard Wright recently remarked, "Computers are advancing, in order to process more information, to generate more effects. [But they are] bereft of any humanitarian ideals ..."[20]

Have we really become cyborgs? And is our ultimate goal, at this point, to leave our "proper body behind and [float] in the immaterial"?[21]

To Hear: The last element "is to one side of the installation, mounted onto the wall with each of its individually shaped components. The word *entendre* [to hear] is placed over the photograph."[22] With this last element, Bélanger proposes that we "listen to" silence. There is nothing to hear, no matter how close we come to the object or how intensely we scrutinize it.

This silence and the lack of response from the object are unexpected. Up to this point, *The Silence of the Body* has encouraged an increasingly empathic response to its various parts, so our first reaction to the ear is disbelief. The previous sensory engagement has faded, and we are asked to "coldly" reflect on the silent and frozen image. What is this silence that we are asked to consider? How can we bridge the gap that has suddenly been created? This quiet moment offers the possibility to speculate, perhaps, on the many unresolved questions that new technologies pose to us as human individuals and as a means to make art. The sudden silence requires us to reflect on the gradual and silent merging of our bodies with the machine.

Although Bélanger proposes a largely conceptual enactment of a cyborg state, Catherine Ikam demonstrates that cybernetics now allows the replication of beings in cyberspace. *Love Story* (1995, a work in progress), shows such a reconstituted being. The work, which relies on "numerical molds" (based on measurements of body parts), is a three-dimensional simulated portrait of her partner. Presenting this portrait in various phases of realization, Ikam demonstrates that we have now reached the stage where our image can be controlled digitally. All boundaries between biology and technology and the natural and the social have fallen, as we have moved to the other side of the screen.[23] No longer fractured in two, we exist within new borders and in a new territory, having left the world as we know it. The next step, of course, is to infuse our cyborg being with human intelligence and emotions. Although it would have been inconceivable to seriously suggest such a possibility a few years ago, it would now seem that this is not so remote a possibility.

Surveillance

About midway into the exhibition, just as we are about to enter Sylvie Bélanger's installation in the McLean Gallery, we may feel a slight discomfort: we experience the sensation of being watched, without, perhaps, realizing why. To the left, overlooking us, is *I/Eye* (1993) by Bill Spinhoven. The work is simple: a single monitor with the image of any eye occupying entire surface.

As we examine the work more closely, we realize that the eye is fixed on us, following our movement and absorbing our gaze. Ironically reversing the usual process of engagement with artworks, *I/Eye* views the viewer. The work also reminds us of the surveillance mechanisms that loom alone in most public environments, including art galleries, and that most of the works discussed so far would not exist without the assistance of such devices. In art, these devices provide the means to reflect on the possibilities and conditions of cyberspace, but in life they both intrude on and control human behaviour. Should we not be wondering how soon and how else surveillance mechanisms of all kinds may monitor our activities? The devices generally serve the "public good," but to what degree do they infringe on other rights, such as the right to privacy?

New Social Spaces

Möller's and Fleischmann's work, as well as Campbell's *Digital Watch*, involve a process whereby a person's consciousness is reconfigured by solo interaction with his or her own image. As a result, our attention is focused on the machine and its method of processing our image. In contrast, works such as Campbell's *Untitled (for Heisenberg)* develop subjectivity through interaction with other beings. By itself, this opens yet another field of possibility and speculation.

One of the differences, of course, between our world and the world of cyberspace is that there desire is no longer (totally) grounded in physicality.[24] Nor are there any rules except those rules that we, individually, wish to carry over into the new space to express in our new personae, and those rules imposed on us by the programming processes of a cyber environment. It is also open to us with whom we identify or even as whom we reconstitute ourselves. As Stone says, "Will the future inhabitants of cyberspace 'catch' the engineers' societal imperative to construct desire in gendered, binary terms – coded into the virtual body descriptors – or will they find more appealing the possibilities of difference unconstrained by relationships of dominance and submission?"[25]

For the development of *Untitled (for Heisenberg)*, Jim Campbell relied on the male/female dichotomy. However, as a person's image, male or female, is projected into cyberspace, this male/female gender code is inevitably deconstructed. Furthermore, desire remains our own. Although our image may be manipulated by the hidden mechanisms of the work, no such control exists over our emotions or the feelings we may experience as a result of that projection into an alien and private social space. The illusion here can be compared to that currently existing in video games: "delegat[ing our] agency to body-representatives that exist in an imaginal space contiguously with representatives of other individuals."[26]

This process engenders our passage into not only a cyborg being but into a cyborg state, as the body-representatives or virtual beings simultaneously become "a container for the self" and a "vehicle for the mind."[27] "From the protein-based life form comes the flexibility and sophistication of a highly complex analogical processor that includes sensory, unconscious, and conscious components; from the silicon-based entity come massive storage

and combinatorial ability, rapid retrieval, and reliable replication."[28]
"Being able to occupy a virtual space implies that one can have the
benefits of physicality without being bound by its limitations."[29]

The more that works such as this one appear to give us con-
trol over our presence in cyberspace, the greater is the possibility of
effecting changes in social conventions. The old rules may be dis-
pensed with to create a new world that lacks the assortment of
restrictive classifications we have so far endured. The new social
spaces, Stone says, become "an imaginary locus of interaction cre-
ated by communal agreement."[30]

The question whether we can really experience the space as if
we were there, while still standing outside as viewers, is an inter-
esting one. It is certainly possible to see ourselves in the space and
find reembodiment in a body-representative, but can we, other
than conceptually, truly feel how it is being there? As Hayles has
pointed out, "Our sense of our physical bodies, their capabilities
and limitations, boundaries and extensions, deeply informs both the
objects and the codes of representation. Less clear are the implica-
tions of these mappings. In this last decade of the twentieth century,
elisions between physical and textual bodies are entangled with
complex mediations that merge actual and virtual realities, ideolog-
ical and technological constructions."[31]

If power and mastery can be said to drive scientific research,
cultural theorists like Hayles, as well as artists, are impelled to dis-
cover what happens to the physical body and to perception in the
infinity of cyberspace.

Within *Press/Enter*, a number of artists extend, as Vivian
Sobchack termed it, "our presence spatially – transforming the
'thin' abstracted space of the machine into a thickened and con-
crete world."[32] At the same time, most people remain sceptical

about cybernetics. This scepticism is also evident in the work of George Bures Miller, Jim Campbell, and Julia Scher.

George Bures Miller's *Conversation/Interrogation* (1991) relies on a very basic set-up. Consisting simply of a video monitor, an office chair, and a surveillance video camera, the work invites the viewer to sit down. As soon as she or he complies, an image of a man appears on the screen and begins a conversation with a person off-screen left. The video soon cuts to this person, who, in fact, is the viewer himself or herself, now on the screen. A conversation appears to be taking place between the viewer and the man originally on the screen. The work draws on the now well known television-interview convention: we see two people apparently conversing in real time, but in fact the footage of each may have been shot separately, at different places and times, and edited. In this work, as on TV, a computer controls the edits between the taped video signal and the live one. What makes this work compelling is the ambiguity – and the resulting humour – of the relationship between the two people. It is never clear whether the conversation is between friends, whether it is a job interview, or even an interrogation. Furthermore, as part of the exchange is based on the male/female dichotomy, some of the scenes turn into a sort of theatre of the absurd if the viewer is not a member of the sex that fits the story-line. Out of this ambiguity also emerges the awareness that the scene, however real it might look, is a fiction and that within this fictional reenactment we are voiceless and helpless, at the mercy of the speaker with his agenda and the technology the work uses. What in the end transpires is the ease with which our presence can be recontextualized and our intentions altered. As both subject/ viewer and object/"manipulatee" within and outside the work's parameters, we come to doubt our own identity and feel discomfort at how readily we have been coerced into a predetermined role.

In *Memory/Recollection* (1990), Jim Campbell takes this notion to another level. This work involves a dual process that consists of capturing live images on the monitor and recontextualizing them, drawing from a bank of images stored in the computer's memory. The image of the viewer thus registered gradually fades from the first monitor to the last one. At the same time, images of previous viewers are retrieved, so the current viewer finds himself or herself surrounded by other people; later, this person becomes part of the other people's "background."

We suddenly find ourselves in the midst of people when no one is there. The effect is disturbing. We have learned to trust our perception of others' nearness. Even when someone silently approaches from behind, we tend to feel that presence. Such reliance on instinct is undermined in this work.

That our image, once digitalized, has passed from our control and can be manipulated to affect both the nature and the meaning of the role we play is also taken up by Julia Scher. *Predictive Engineering* (1993) lays bare the paraphernalia of technology: exposed cables, uncovered monitors, watchful cameras, and visible control mechanisms. Entering the space of the work is somewhat like walking into a television studio or, a better analogy, the security control room of an office building. At this level, the work does not pretend to be other than what we see.

Trapped in such an environment, we find our attention soon drawn to the monitors that show our presence in real time in the space. Interspersed with these shots are others from other locations in the gallery. Prerecorded, this last series of images relies on fictitious scenes that include outrageous behaviour. The work also incorporates references to the actual works in the installation, mixing facts as we know them with information that has been

invented. Superimposed on the images are graphic frames, legends, icons, and data, all of which reinforce the control and codification that our image is being subjected to. Finally, animating these images are occasional fragments of texts delivered in a robotic voice: "Do not leave until the cameras have completely absorbed you" or "Palm identification and retinal scan ... on now!" or even "Accidental injections taking place, now!" In *Predictive Engineering*, technology has taken charge completely. Coding and analyzing our presence, the work shows how we have lost control not only of our body – which, in this context, has become a manipulated object – but how easily human perception can be conditioned. Exploring the anxiety that new technologies pose, Scher turns common and widely used security devices into a nightmare of everyday life, where any notion of difference between the actual and the reconstructed or between fact and fiction is erased. As the artist herself observes, "We are increasingly aware that although [it is] 'live,' we watch surveillance imagery as the registration and display of a file. In the future, what will it mean to see our image file[d] in different circumstances."[33]

With Luc Courchesne's *Family Portrait: Encounter with a Virtual Society* (1993), we find ourselves actually engaging in conversation with virtual beings. The work suggests amazing possibilities for the future, when people may program made-to-order environments that would conform absolutely to their own private emotional and social needs. Making reference to a new type of social environment that exists at a nonvisual level on the Internet, *Family Portrait* also suggests the potential for social alienation in a world where virtual interaction would take precedence over real exchanges between people.

In this work we can talk to virtual beings and the virtual beings are apparently aware of our presence and of each other. At certain

times they take charge, interrupting their conversation with us to engage in a dialogue between themselves. They also determine whether they wish to become more intimate with us: at first they answer our questions willingly enough, but there may come a point when, dissatisfied with the direction our questions are taking, they decline to continue the exchange. This is a privilege we thought we, as humans, had over the machine, but this work suggests that we might not always have it. Already those of us relying on computers know how easily text can be lost or altered through our slightest inattention. This work puts us even more at the mercy of the machine, paying us no more attention than the other virtual beings in the room. It even goes so far as to subject us to its "emotional" tantrums.

Poetic Intimacy

Edmond Couchot's *Je sème à tout vent (plume* et *pissenlit)* (1988, 1992) neither embodies our image nor recreates a social space. Its process, however, is as involving as any of the others. *Je sème à tout vent* invites the viewer to blow on the image of a feather and/or a dandelion seed, causing the image to drift, float, and rest again in the space. Our own existence fuses with that of the image. Nowhere, perhaps, is being a cyborg as easy and as convincing as here.

What makes this work so compelling, perhaps, is both its poetic simplicity and its reference to childhood, when, having nothing better to do, we take pleasure in blowing dandelion seeds to the wind. The seeds of technological progress are similarly blown, *à tout vent*, into our lives. Are we too, like even the most careful gardener, unaware until the dandelion has taken root?

Notes

Author's Note: Works by Jim Campbell (*Untitled [for Heisenberg]*), Christine Davis, and David Rokeby were written about while the pieces were being developed by the artists. The reader might then find some slight discrepancy between the works as they finally evolved and the way they are discussed here.

1. Allucquère Rosanne Stone, "Will the Real Body Please Stand Up?: Boundary Stories about Virtual Culture" in *Cyberspace: First Steps*, ed. Michael Benedikt (Cambridge, Mass., and London, Eng.: The MIT Press, 1991), 107.

2. Stone, 107.

3. Bruce Clarke referred to by N. Katherine Hayles in "The Seductions of Cyberspace" in *Rethinking Technologies*, ed. Verena Andermatt Conley on behalf of the Miami Theory Collective (Minneapolis: University of Minnesota Press, 1993), 180. Scott Bukatman quoted by Hayles, 186.

4. Hayles, 186.

5. Hayles, 186.

6. Hayles, 186.

7. Hayles, 186.

8. Hayles, 186.

9. François Dagognet, "Toward a Biopsychiatry" in *Incorporations*, ed. Jonathan Crary and Sanford Kwinter (New York: Zone Books, 1992), 520.

10. Hayles, 185.

11. See Nam June Paik, "Videocryptography" in Pierre Restany, *Catherine Ikam* (Nimes: Adrien Maeght Éditeur, 1991), 28.

12. Paik, 30.

13. Sadie Plant, "Beyond the Screens: Film, Cyberpunk and Cyberfeminism," *Variant* 14, Summer 1993: 16.

14. For a more detailed analysis of this work, see Louise Dompierre in *Carambolage II: Sylvie Bélanger: Le Silence du Corps* (Grenoble, France: Le Magasin, 1994).

15. Dompierre, 16.

16. Sylvie Bélanger in *Sylvie Bélanger: The Silence of the Body* (Oakville, Ont.: Oakville Galleries, 1994), 32.

17. "A cyborg is a cybernetic organism, a hybrid of machine and organism, a creature of social reality as well as a creature of fiction." See Donna Haraway, "A Cyborg Manifesto: Science, Technology, and Socialist-Feminism in the Late Twentieth Century" in *Simians, Cyborgs, and Women: The Reinvention of Nature* (Routledge, Chapman and Hall, 1991), 149.

18. Haraway, 150.

19. Bélanger, 32.

20. Richard Wright, "Soft Future" in *Variant* 14: 6.

21. Plant, 16.

22. Bélanger, 32.

23. Stone, 95.

24. Stone, 106.

25. Stone, 106.

26. Stone, 94.

27. Hayles, 176.

28. Hayles, 177–78.

29. Hayles, 179.

30. Stone, 84.

31. Hayles, 174, 175.

32. Stone, 106.

33. Julia Scher, "Mass Observation" *Ten 8* 2, no. 2, (September 1991), n.p.

RIGHT
John Massey
Bridge at Remagen 1985
Photo: Peter MacCallum

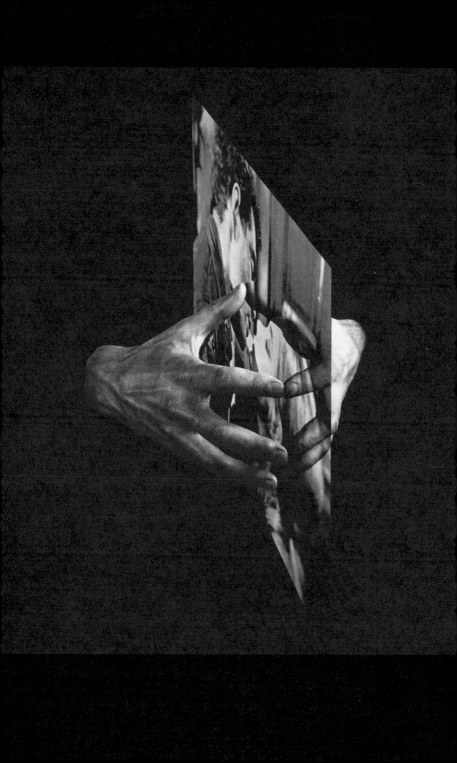

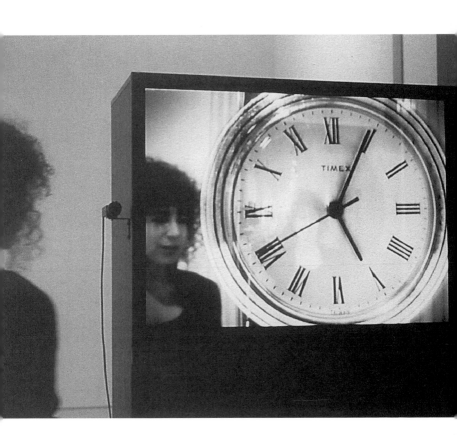

Jim Campbell
Digital Watch 1991 (Detail)
Photo: Courtesy of the artist and San
Francisco Museum of Modern Art

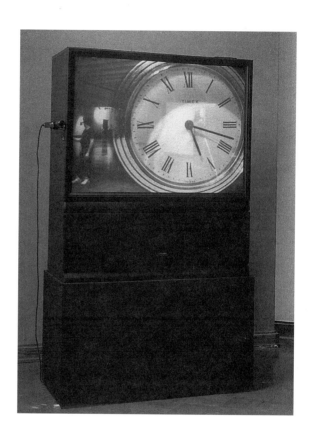

Jim Campbell
Digital Watch 1991
An interactive work that returns the
viewer's image both in a mirror and
a cybernetic state.
Photo: Courtesy of the artist and San
Francisco Museum of Modern Art

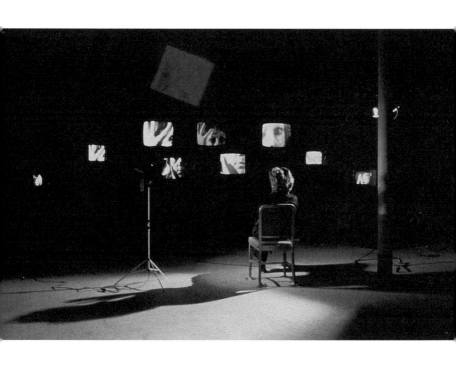

Catherine Ikam
Identité III 1980
Fragmented images of the viewer's face as
he/she sits in the chair facing the monitors.
Photo: Courtesy of the artist

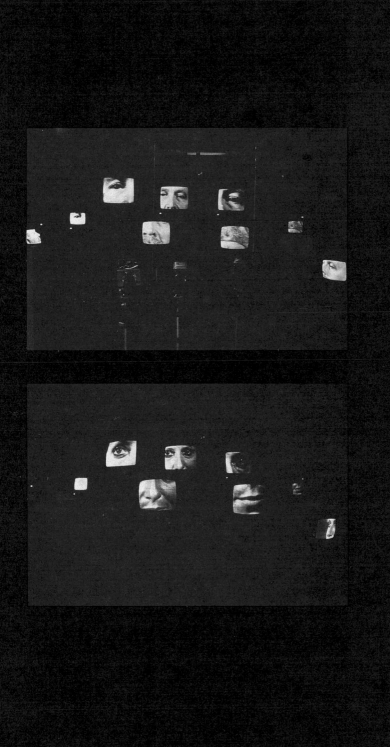

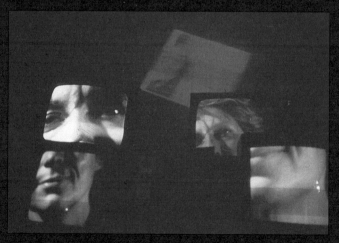

LEFT AND ABOVE
Catherine Ikam
Identité III 1980 (Details)
Photo: Courtesy of the artist

THE DESIGN OF VIRTUAL REALITY

Michael Heim

Why Call It "Virtual Reality"?

The label "virtual reality" stuck to the new technology and just wouldn't let go. Since Jaron Lanier coined the phrase in 1986, it has held the field through all opposition. Researchers at MIT shunned the phrase in the early 1990s. Instead of "virtual reality," they spoke of "virtual environments." The word "reality" in "VR" glowed with an aura similar to "artificial intelligence," and computer scientists had been burned once before by boldly promising to deliver machines that could think. At the University of North Carolina, engineers under Frederick Brooks found "virtual reality" unscientific. They too opted for the more buttoned-down "virtual environments." Military scientists preferred "synthetic environments." Researchers at the Human Interface Technology Lab at the University of Washington in Seattle urged "virtual worlds." Against all protests, however, Lanier's phrase held its own. "Virtual reality" continued appearing on successful grant applications as researchers conceded the power of VR to describe their holy grail. The poetic appeal of the phrase, its grandeur, struck the appropriate chord for the English-speaking community. Appropriate too was the subtle reference of the phrase to the historical origins of computing. The philosopher Leibniz was famous for his proto-computer, as well as for his metaphysics of "possible worlds."

The philosophic echoes in the term "virtual reality" serve perfectly well to suggest today's ambiguous merger of life with computers. Grammarians complain about the oxymoron "virtual reality," but the semantic twist of the phrase tells us as much about our tenuous grasp on reality as it does about the computerization of everything we know and experience. "Virtual" implies the computer-storage model of life, software tricks, and the switch from industrial physics to information symbolics. Software now belongs to the substance of life. Life's body is becoming indistinguishable from its computer prosthesis.

Not surprisingly, the first steps in virtualization are appearing in children's toys. The next generation will take for granted the powerful transformation that makes us pause today. Entertainment, not philosophy, shows us the first merger of computers with reality. Arcade games, CD-ROM fantasies, and location-based theme parks beguile our human sense of presence. We find ourselves going back to the future, visiting the stars, and walking through *Star Trek*'s Holodeck. More delight here than philosophy. Beyond the glint of the coins, however, we can see the outlines of a new kind of art. And this art is a reflective mirror where philosophic thinking captures a first glimpse of the coming ontology. This art may also help design virtual worlds that enhance rather than threaten our health and sanity.

The Joystick in the Mirror

Art holds a mirror to our deeper selves, displaying our fears, hopes, and doubts. Entertainment, by contrast, exploits a narrow range of excitement. The repeated stimulation of entertainment shrinks us, but the contemplation of art expands our scope. Because of its expanding scope, art reveals the meaning of our interplay with virtual-reality entertainment.

As VR today develops mostly in the field of entertainment, the big picture of what VR could be tends to get lost in the rush for "content" to "fill" the new medium. It's up to artists to guard the visionary aspects of technology. Art nurtures infant technologies like virtual reality. Art lifts a mirror to show the power and peril of nascent technologies.

No accident, then, that art should preserve our ambivalent attitude towards technology. From its Greek origin, art is *techne*, the skill of making and producing. As primal making, art preserves the surprise of its own emergence. Rather than lose itself in the thrill of content, art lingers over its own birth, remaining ambivalent towards its own existence. In this way, art resembles its sibling, philosophy. Philosophy too dwells on its own origin, continuously redefining itself.

Art parts company with philosophy and technology when the artist produces harmonious things. Then art becomes *ars* or joining (Latin) when the things produced show a splendid integrity. Compared with the harmonious products of art, the conceptual products of philosophy seem pale and ineffectual and the products of technology often seem a maze of techniques for the sake of technique. We must design technology back into the essence of art. In that way, technology can recover its own meaning. Art and technology: two sides of the same cultural process. The joystick in the mirror.

Alternate World Syndrome

In March 1994, I spent six hours in virtual reality at the Banff Centre for the Arts in Alberta, Canada. There I donned a head-mounted display and for three hours on two evenings explored the "Virtual Dervish" created by Marcos Novak, Diane Gromala, and Yakov Sharir. My journal from that period reveals the discord I call Alternate World Syndrome.

> Three hours into the Virtual Dervish, my optic nerves are imprinted with brightly colored structures. After hours of immersion in the 360-degree simulation, I can later summon the computer-generated images with the slightest effort – or see them sometimes in unexpected flashes of cyberspace. Hours later, I still felt a touch of perceptual nausea, a fore-warning of the relativity sickness I call "Alternate World Syndrome." Everything seems brighter, even slightly illusory. Reality afterwards seems hidden beneath a thin film of appear-ance. Perceptions seem to float over a darker, unknowable truth. The world vibrates with the finest of tensions, as if some-thing big were imminent, as if you were about to break through the film of illusion.

Alternate World Syndrome (AWS) is an acute form of body amnesia that can become chronic Alternate World Disorder (AWD). Frequent virtuality can lead to ruptures of the kinesthetic from the visual senses of self-identity, a complaint we already know from simulator sickness and from high-stress, techno-centred lifestyles. AWS mixes images and expectations from an alternate world so as to distort our perceptions of the current world, mak-ing us prone to errors in mismatched contexts. The virtual world obtrudes on our activities in the primary world, and vice versa. The responses ingrained in the one world get out of sync with the other. AWS shows the human being merging, yet still out of phase, with the machine.

The lag between worlds is not the same as the lag between the head-mounted displays (HMD) and the user's eye movement. The HMD lag comes from a timing defect, which computer hardware development will eventually remedy. The AWS lag occurs between the virtual body and the biological body. The lag comes not from asynchronous interruptions within the virtual experience but from the sequential switching between worlds. A conflict of attention, not unlike jet lag, arises between the cyberbody and the biobody. A world, in the deepest sense, is a whole context of involvements based on the focal attention of the world's inhabitants. We feel a switch between worlds when we visit a foreign country, though the foreign world is cultural, not virtual. When a user identifies with a world, it then becomes an existential reality – even if only a virtual reality.

AWS occurs when the virtual world later obtrudes on the user's experience of the actual world, or vice versa. AWS is simulator sickness writ large. Researchers who compare VR with military simulators remain pessimistic about the widespread use of VR. Many pilots cannot use simulators, and even those who train in simulators are grounded for days afterwards. Simulator experience counts towards upgrading a pilot's licence to more powerful aircraft, but the hazards of simulator sickness exclude a large portion of pilots from upgrading their licences in this way. Drawing on their studies of simulators, many military researchers believe that the population at large could not regularly spend hours in virtual environments without suffering serious side effects.

AWS is technology sickness, a lag between the natural and artificial environments. The lag exposes an ontological rift where the felt world swings out of kilter. Experienced users become accustomed to hopping over the rift. Dr. Stephen Ellis, scientist

at NASA / Ames and at the UC Berkeley School of Optics, says that his work in VR often has him unconsciously gesturing in the primary world in ways that function in the virtual world. He points a finger, half expecting to fly (as his cyberbody does under the conventions of the virtual world). His biobody needs to recalibrate to the primary world.

AWS is not an avoidable industrial hazard like radiation overexposure but comes rather from the immersion intrinsic to virtual world systems. Immersion is the key feature of VR systems. Virtual reality in general immerses the user in the entities and events of the computer-generated world, and the immersion retrains the user's autonomic nervous system. The human learns to respond smoothly to the virtual environment, but the frequent readaptation to the technology affects the psyche as the virtual world injects its hallucinatory afterimages into the primary world.

Observe someone coming out of a VR system such as W Industries' Virtuality arcade games. Watch the first hand movements. Invariably, the user stands in place a few moments (unless hurried by the system's administrator), takes in the surroundings, and then pats torso and buttocks with the hands – as if to secure a firm landing and return to presence in the primary body. The user feels a discrepancy on returning to the primary world. The discrepancy marks the gap between the virtual and the biological bodies. The virtual body still lingers in the afterimages and the newly formed neural pathways while the primary body resumes its involvement in the actual, nonvirtual world.

The Bright Side of AWS

But there's a bright side to AWS. The only reason we have to worry about AWS is that VR has such awesome imprinting power. The virtual environment sucks in its users with a power unlike any other medium – unless we include under media the religious rituals and sacred dramas that once gave artworks their context. The fascination of VR recalls the linguistic root of the word "fascination," which comes from the Latin (*fascinari*) and which refers to someone's gaze being drawn repeatedly towards the dancing flames of a fire. From the viewpoint of human evolution, VR resembles the invention of fire. To understand the power of VR, we have to return to the cave. Or, I should say, both caves: the cave of the Paleolithic era, and the one known as "Plato's Cave."

The earliest human beings learned to select items from their experience and then taught themselves to focus on those items of experience. Bison, horses, birds all became prime items for early human vision, as well as targets for human consumption. From the cave paintings at Lascaux and Altamira (c. 14,000 B.C.), we know that humans have always enhanced their visionary powers through drawings and paintings. Because the caves gave them rest from the constant fight-or-flight stresses of survival, early human beings learned to sit by the fire and meditate, visualizing the realities cast by a flickering light on the shadowy walls of the cave. Fire first nurtured the human powers of visualization. Tending the dangerous fire forced humans to reflect on their activities and then to specialize and divide their tasks. A new human society emerged from the technology of fire and the visionary experiences of light in the cave. Fire was wonderful and dangerous.

Long after the Paleolithic age, the Athenian philosopher Plato (c. 427 – 347 B.C.) made vision the keystone of reality. He followed Socrates in locating human intelligence in the ability to see

things clearly with the mind's eye (Plato invented the term "mind's eye"). Plato gave a name to the mental forms that guide humans and he called them "ideas" (Greek idea means "shape seen," a term used by Greek sculptors). Ideas, according to Plato, govern reality – whether they are the ideas in the mind of God or the ideas in the minds of human beings. Clear mental vision, according to Plato, is the responsibility of education in the truest sense – not training or skill or social conformity. Only through ideas do human beings come in contact with "true reality" (Plato's term).

Plato's influence continued through the Renaissance and well into the modern period. Even when the physical sciences abandoned idealism for the sake of empirical experiments, Platonic visionary idealism still continued quietly in the background. Students of public speaking, like the rhetoricians mentioned by Frances Yates in her book *The Art of Memory*, used visualization techniques to enhance thinking on their feet. Renegade scientists, like Giordano Bruno and Isaac Newton, employed complex images and mental maps to focus their thinking. Many were considered heretics for dabbling in occult symbols, but all followed the lead of the first humans who bootstrapped intelligence by using images to internalize new realities. Through the experiments of artists and of military trainers, we are coming into possession of an incredibly powerful visualization tool. In fact, to call it a tool may be to understate its power. VR may actually transform the way we learn and think and deal with things. Tools that transform us, like fire or the wheel or the automobile, become integral parts of our destiny, parts of ourselves. Such devices cause us to evolve and eventually mutate. VR will very likely transform the culture that uses it.

Educators and learners can channel this visionary device to bring us to a higher level of civilization. From the past uses and abuses of technology, however, we can safely guess that VR will bring negative as well as positive developments. Recall Plato's Myth of the Cave. In it, Socrates tells a story of enlightenment, but it is also a story about enslaving addiction, upheaval, homicide, and a vision so passionately beautiful that it brings death to the person who catches a glimpse and then dares to share it with others. We need to reflect again on this story of the Cave.

VR Does Not Re-present, VR Tele-presents

Everything in life is, of course, a risk. But no artifact so insinuates itself into the inner sanctum of the mind as computer-generated images. And when the images become virtual entities and virtual agents, then we find something very special about the environments generated by VR. We have always been able to immerse ourselves in the worlds of novels, symphonies, and films, but VR insists that we move about and physically interact with artificial worlds. This sensory immersion is a special feature of VR.

Sensory immersion has broad ontological implications. First, virtual entities are not representations. They do not re-present. They do not "present again" something that is already present somewhere else. Even telepresence robotics brings about a transformation of the remote entity, in which its properties become open to manipulation in new ways. The telepresent doctor reconstitutes the patient and thereby creates a new doctor-patient relationship through telepresence surgery. Virtual images are not like the images in paintings, which we can mistake to be an outside entity

and which the graphic image represents. In VR, the images are the realities. We interact with virtual entities, and we become an entity ourselves in the virtual environment. As in the medieval theory of transubstantiation, the symbol becomes the reality. This is the meaning of telepresence.

Telepresence is the cyberspace where primary entities are transported and transfigured into cyber entities. As another layer of reality, cyberspace is where the transported entities actually meet. They are present to one another, even though their primary physical bodies exist at a distance (the Greek *teles*). When a virtual world immerses a user in a virtual world, the entities encountered in the virtual world are real to the user – within the backdrop of cyberspace. The user inhabits the world and interacts with virtual entities.

Granted that immersion belongs to VR, the question remains: How are users best immersed in virtual environments? Should users feel totally immersed? That is, should they forget themselves as they see, hear, and touch the world in much the same way as we deal with the primary phenomenological world? (We cannot see our own heads in the phenomenological world.) Or should users be allowed and encouraged to see themselves as cyberbodies? Should they be aware of their primary bodies as separate entities outside the graphic environment? Or should they suspend physical experience? What makes full-body immersion? The different answers to this question split off in two directions. One goes into the CAVE at the Electronic Visualization Lab (EVL) at the University of Illinois in Chicago and another goes into the head-mounted displays of Thomas Furness, Frederick Brooks, and Jaron Lanier.

The HMD type of VR is the most widely familiar as it uses the obvious hardware of helmet and data gloves. The projection type

of VR is less widely known as it requires supercomputers to project its graphics. In five years the hardware will become more widely available, so that the VR projection will be part of the home "edutainment" centre. The projection type of VR derives from the early work of Myron Krueger and appears today in the CAVE at EVL. The CAVE is a surround-screen, surround-sound system that creates immersion by projecting 3D computer graphics into a 10'x 10'x 10' cube composed of display screens that completely surround the viewer(s). Head and hand tracking systems produce the correct stereo perspective and isolate the position and orientation of a 3D input device. A sound system provides audio feedback. The viewer explores the virtual world by moving around inside the cube and grabbing objects with a three-button wandlike device. Unlike the HMD type of VR, the CAVE does not require users to wear helmets. Instead, they wear lightweight stereo glasses and walk around inside the CAVE as they interact with virtual objects. Multiple viewers often share virtual experiences and carry on discussions inside the CAVE. One user is the active viewer, controlling the stereo projection reference point, while the other users are passive viewers.

Tunnel VR and Spiral VR

Philosophically, the difference between the CAVE VR and the HMD VR is profound. The HMD brand of VR produces what I call Tunnel VR or perception-oriented immersion. The projection or CAVE brand of VR, on the contrary, produces Spiral VR or apperceptive immersion. The VR that tunnels us down a narrow corridor of perceptions differs subtly but profoundly from the VR that spirals us into higher layers of self-perception.

Let me explain Tunnel VR and Spiral VR. Then I will clarify what I mean when I say that Tunnel VR is a perceptive immersion, and Spiral VR is an apperceptive immersion.

First, we need to distinguish perception from apperception. The term "apperception" arose in the late eighteenth century when Immanuel Kant first made the distinction. Perception goes towards entities and registers their colour, shape, texture, and other properties. Percepts have sensory qualities we perceive with our eyes, ears, nose, skin, or kinesthetic sense. Apperception, on the other hand, perceives not only entities but also notices that which accompanies the perception of any entity: our self-activity. With perception we see something. With apperception we notice that we are seeing something. Apperception implies a reflectedness, a proprioception, a self-awareness of what we are perceiving. For Kant, this aspect of perception means that human beings enjoy a freedom and self-determination in their sensory activity that animals do not. Kant also believed that apperception makes possible a critical attitude towards what we perceive. Once we sense our separation from a stimulus, we can then enjoy the option of responding in various ways to the stimulus, perhaps even choosing not to respond at all.

The term "apperception" allows us to highlight the advantage one type of VR immersion has over the other. In perception-oriented VR, the head-mounted display shrouds the user's head much like the hood that covers the head of a pet falcon. Such falcon-hood immersion derives from not having a choice about where to look. The falcon grows tame under the hood because it is temporarily blind to the larger world. Likewise, the HMD immersion results from the primary body giving way to the priority of the cyberbody, and a tunnel-like perception of the virtual world results. In this

sense, the HMD graphic environment is tunnel vision. The user undergoes a high-powered interiorization of a virtual environment but in the process loses self-awareness. (Discomfort alerts your attention but also detracts from an optimal and fully present awareness of self and world.)

In the CAVE or projection VR, the user typically experiences more than the perception of entities. The user enjoys an apperceptive experience. Because the user's body is immersed without having to adapt to the system's peripherals (heavy helmet, tight data glove, calibrated earphones), the CAVE immersion does not constrict but rather enhances the user's body. In turn, the projected immersion shows a different phenomenological landscape than perception-oriented systems. Most computer immersions are perceptive immersions. Typically, computer graphics produce a representation of entities. They show us things we can then constitute with our imaginations. The immersion comes about through psychological suspension of selfhood.

Phenomenologically, HMD immersion renders entities directly. We see not only what the graphic images refer to, but we identify with them. Like the kid in the shoot-'em-up arcade game, we squint down the tunnel to lose ourselves in becoming characters in the game. In VR, we see virtual entities. Graphics refer us to things. But, like the pet falcon, we are directed by HMD VR exclusively towards the entities, into a tunnel-like perceptual field in which we encounter the graphic entities.

Apperceptive immersion, on the other hand, make us feel ourselves perceiving the graphic entities. Our freedom of bodily movement permits us to remain aware of ourselves alongside computer-generated entities. Apperceptive VR directs us towards the experience of sensing the virtual world rather than towards

the entities themselves. To put it simply, HMD VR creates tunnel immersion, but apperceptive VR creates a spiral telepresence that allows us to go out and identify with our cyberbody and the virtual entities it encounters and then return to our kinesthetic and kinetic primary body, and then go out again to the cyberbody and then return to our primary body, all in a deepening reiteration. The spiral of telepresence can work like a conical helix that ascends upwards, taking us to new dimensions of self-awareness. Instead of *Tron*, we have the *Mandala* system. Instead of *Mortal Kombat* or *Doom*, we have *Myst*.

Not by accident was the first commercial style of projection VR named *Mandala*. The mandalas of Asian art oscillate between outer perception and inner self-awareness. Unlike the hero of the film *Tron*, we do not entirely lose ourselves in Mandala immersion. In the realm of CD-ROM design, *Doom* or *Mortal Kombat* channel our energy down single paths of identification and the charm of *Myst* is to stun us repeatedly into becoming more aware of our lostness, of our powers of exploration, of our sense of mystery. Of course, current multimedia CD-ROMs work only by analogy to VR. Present-day CD-ROMs show only the desktop through-the-window view of a virtual world, and as such always remain an abridged and diminished form of virtual experience. Nevertheless, the issue of interactivity in multimedia seems also to fall under the critical issue of perception / apperception.

HMD systems allow us to go "through the window" and engage computerized entities, but apperceptive systems like the CAVE allow us to go further. If we could employ both hardware systems in the same proximate framework, then we could enter cyberspace and at the same time celebrate the free play of our physical bodies.

The difference between perception and apperception VR systems means more than an ergonomic difference, however. The difference goes beyond physical comfort. Users often appreciate the freedom of movement possible with unencumbered VR, and the word "unencumbered" expresses that freedom. But "nonencumbered" remains a merely negative definition, telling us only what this type of interface is not. By apperceptive VR, I suggest a positive definition of one of the crossroads facing VR development.

From the viewpoint of user phenomenology, the difference is one of the felt experience of the self. One supports a focused self and the other supports an expansive self. When we are not strapped into a helmet and data suit, we can move about freely. The freedom of movement goes beyond feeling unshackled. It also means our spontaneity becomes engaged. Just watch for a few minutes the users of projection VR, how they turn and bend and move their bodies. Then contrast this with HMD users. The difference lies not only in the software or the environment rendered. The difference lies also in the hardware-to-human interface.

The creators of the CAVE implicitly grasped this. By referring to Plato's Cave – Thomas DeFanti fondly and frequently makes that reference – the inventors at the Electronic Visualization Lab recognize the human issue. The human issue concerns the freedom embedded in the hardware-to-human interface of VR. About 425 B.C., the philosopher Plato wrote, in Book VII of *The Republic*, a story he heard from his teacher, Socrates. Socrates' story of the Cave framed a centuries-old debate about the status of symbols, images, and representations. In Socrates' parable, the people chained to the floor of the Cave enjoy no physical mobility, and their immobilized position helps induce the trance that holds them fixed in its spell. They see shadows cast by artificial creatures

("puppets") held up behind them. The puppets have been created by human beings who want the prisoners to accept the shadows as the only real entities. The Cave consequently becomes a prison rather than an environment for spontaneous behavior. Plato's Cave is a dungeon, not to be confused with the caves of Lascaux. Similar to Plato's Cave, the HMD VR can facilitate a higher level of human productivity and an information-rich efficiency – whether for flying aircraft, undergoing training, or holding meetings in a corporate virtual workspace – but it does so by exacting a human price.

Socrates ends his story by having one of the prisoners escape from the Cave. Someone unchains the prisoner, who then walks out of the dark dungeon and then glimpses for the first time the sunshine and the light of real entities like trees and rocks and flowers. For Socrates, the sunshine was the sphere of thinking and mental ideas. As long as the person stays fixed in a purely receptive mode, chained to indirect perceptions, the mind lives in the dark. By climbing out of the Cave into the sun of well-thought ideas, the prisoner ascends to the primary and true vision of things.

Cyberspace, as described in my book *The Metaphysics of Virtual Reality*, is "Platonism as a working product." With its virtual worlds, cyberspace transcends the physical by replacing it with the electronic heaven of ideally organized shapes and forms. To balance this Platonism, we must revise the Cave metaphor. To escape from tunnel VR, we must rediscover the primary world so that this world vitalizes the body that already exists outside electronic systems. Our liberation is to enhance and deepen our awareness of the primary body by directed use of the cyberbody. From the perspective of user somatics, the difference between apperceptive and perceptive VR is one of the primary body versus the cyberself construct. The term "somatics" derives from Thomas Hanna. Hanna

defined somatics as the first-person experience of one's own body – as opposed to third-person accounts of one's body from a scientific or medical point of view. Somatic awareness is the line where conscious awareness crosses over into the autonomic nervous system, breathing, balance, and kinesthetic bodily feedback. The more we identify with a cyberself graphic construct, the less we preserve primary body somatics. Human attention is finite. When our attention becomes stretched and overextended, we feel stress. The HMD tunnel may provide the greatest tool for training and for vicarious experience, but it exacts the greatest price on the primary body.

Tai Chi Telepresence

The reconstruction of the self through virtual reality signals the highest risk in human evolution. If every technology extends our senses and our physical reach, then VR extends us to the maximum because it transports our nervous systems into the electronic environment. If our contemporary culture already stresses and even overextends our finite capacities, then the VR tunnel holds great dangers. We may lose our way in the tunnel. We may lose part of our selves, our health, our body-mind integration down the tube. At the least, we may face a subtle AWS or a more acute AWD.

At the opposite pole of Tunnel VR stands what I call "the Tai Chi body." The Tai Chi body arose in health practices of ancient China, where a series of exercises cultivated a unified meditative awareness. The exercises circulate *chi* ("chee") or internal psychophysical energy, felt body energy. A description of the typical Tai Chi body appears in this brief excerpt from my journal of a few years ago when I described the moments of wordless unity.

The pre-dawn air was pale gray and the ocean breezes cool near Venice Beach in Los Angeles. Every morning for the past several months, I opened the same rickety wooden gate to walk into the backyard of Master Tung, Tai Chi man and Taoist teacher. Quietly I took my position among the ten or fifteen human figures standing like statues under the fragrant eucalyptus trees.

Feet parallel, knees relaxed, spine straight, weight sunk into the balls of the feet, arms outstretched with hands open but relaxed, eyelids nearly shut. Begin letting go of all thoughts, forgetting everything, listening only to the inhale and exhale of the breath. Sink down, letting go of muscle tension, releasing worries and desires, gradually merging the attention with the body. Every few minutes, teacher Tung makes the rounds to adjust the posture, and each time a burst of energy shoots from foot to crown of head. The attention wedded to a relaxed body generates a feeling of inner power, of expanding, radiant energy.

By the time the hour is over, the sun's patterns are flickering through the eucalyptus leaves onto the grass with an incredible but gentle brilliance. Sounds of birds and lawnmowers emerge slowly in the distance. Other students are stirring and moving about in the slow martial movements of Tai Chi Chuan. Awareness of the clock returns gradually.

Later that morning, driving on the freeway, or sitting at the computer, or lecturing in the classroom, I feel the sudden pull of body/mind unity reclaim my nervous system: unnecessarily taut muscles let go, clenched fingers release, breath comes full and supportive.

Or I catch myself in a moment of haste moving as if I were no more than a bundle of competing mental intentions, the body twisting with one limb this way and one limb that, without coordinating breath with action, and without making the most of my centre of balance. The memory of Tung's garden adjusts me.

Tai Chi is a Chinese yoga that arose in a martial arts context hundreds of years ago. It sews together attention and physical body so as to increase the *chi*. The cultivation of *chi* enhances health, joint flexibility, and biofeedback.

What I suggest is that we learn to use Tai Chi – or something like it – to capitalize on the fundamental differences between projection VR and HMD VR. Right now, the two VRs stand in opposing camps in the VR industry. Each type of VR may eventually have its appropriate range of applications, but the two camps may also coalesce into a more effective and healthful system. Let me describe one possible scenario in which the two VRs might merge in the service of the Tai Chi body. From an evolutionary standpoint, the Western technological system may need help from outside cultures in order to lessen its negative aftereffects.

Here's one possible scenario. Because time spent in HMD VR tends to constrain human attention into perceptive tunnel immersion, and because every technological advance exacts a price or trade-off, we should allot a corresponding amount of time for projection or CAVE VR. We should combine projection VR with HMD VR, just as we combine a decompression chamber with scuba diving. Scuba divers check timetables to find a ratio between time spent undersea and time needed in a decompression chamber. They then spend a certain amount of time in the decompression chamber so their deep-sea diving will not cause them to suffer internal injury. Similarly with VR. The VR user should have a corresponding decompression procedure after spending a couple of hours in HMD VR. The CAVE VR provides an analogous decompression insofar as projected VR allows the technology to smoothen the transition from cyberbody to primary body. Rather than feel an abrupt shock between cyber and primary worlds, the user brings

attention back into the primary mind-body and reintegrates the nervous system.

A Virtual Tai Chi master invites you into the CAVE after you release your focus from HMD applications. The Tai Chi Expert is a computer-generated composite that models the movements and postures of actual Tai Chi masters. The computer-generated master teaches not only a series of movements but also adjusts meridian circulation, does push hands, and even spars with sporting users. Such a VR decompression chamber could link users to the primary world smoothly with an intensity that reclaims the integrity of conscious life in biological bodies. The procedure can help offset the disintegrating aspects of reality lags and AWS. The VR experience can grow into a health-enhancing rather than health-compromising experience.

If wisely applied, art can weld the tunnel and the spiral into a single system so the system might bring humans to a higher state of well-being. A combination of apperceptive with perceptive immersion might foster balance. The harmony of both types of VR immersion could produce virtual environments for engendering more alert and self-aware human beings.

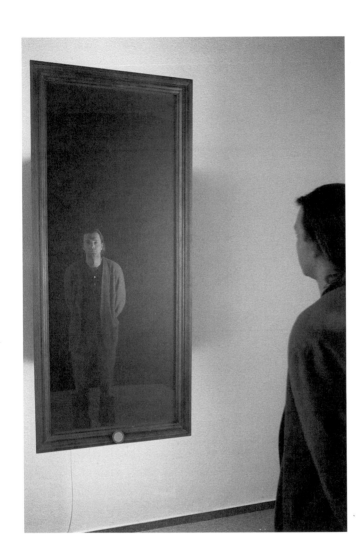

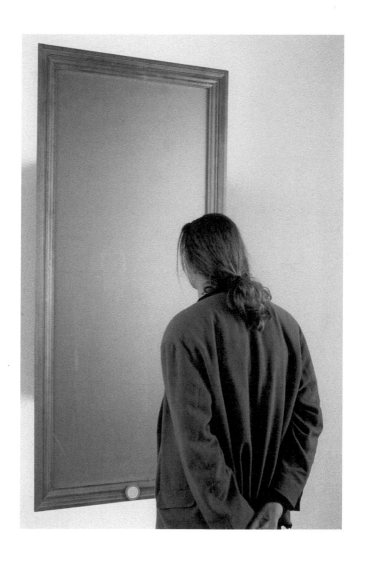

LEFT AND ABOVE
Christian Möller
Electronic Mirror 1993
An interactive work that acts both as a mirror and
as a controlling device over the viewer's image.
Photo: Courtesy of the artist

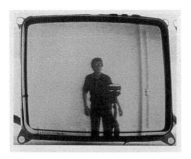

Jim Campbell
Memory/Recollection 1990 (Detail)
Photo: Courtesy of the artist

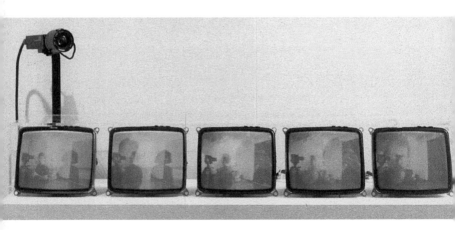

Jim Campbell
Memory/Recollection 1990
An interactive video work that records and stores the viewer's
image, which is recontextualized within the memory bank.

Sylvie Bélanger
The Silence of the Body 1994
An installation in three parts, including projections
and an interactive device that picks up the image
of the viewer and inserts it in the pupil of the "eye"
element of the work.
Photo: Isaac Applebaum

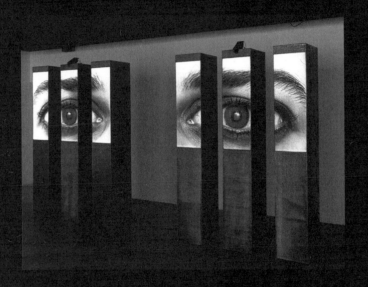

ABOVE AND RIGHT
Sylvie Bélanger
The Silence of the Body 1994 (Details)
Photo: Barri Jones

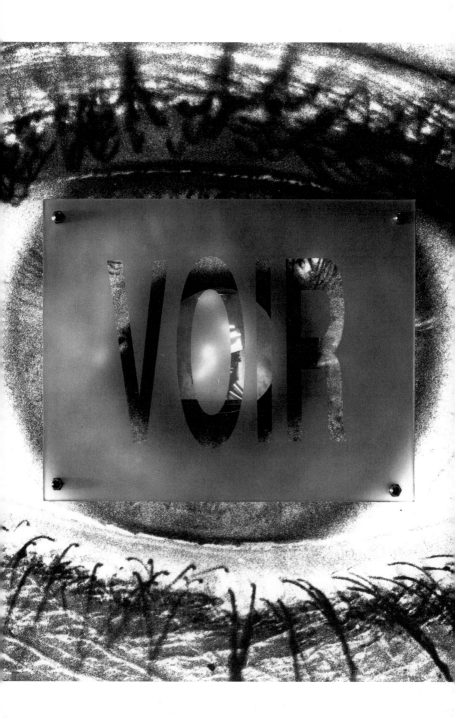

Sylvie Bélanger
The Silence of the Body 1994 (Detail: mouth)
Photo: Barri Jones

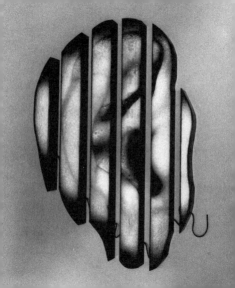

A VOLCANIC THEORY of ART

Derrick de Kerckhove

Art and Technology

As you walk across the hall on the ground floor of The Power Plant gallery, you are being followed by an eye trained right on you. Bill Spinhoven's *I/Eye* (1993) challenges you to reconsider the relationships between vision and selfhood. Is this just an eye? Or is there something behind the video-gaze, a watching presence – in other words, a self? You are puzzled by this paradoxical – read "virtual" – presence, which you cannot altogether accept or deny. You are also puzzled by the nature of the experience you are going through. What are you to make of this? Should you enjoy it? Or is this just a trick, a kind of exaggeration of gadgetry?

Spinhoven looks at common technologies such as surveillance systems but brings out features that we might not have seen or felt otherwise, in a way that says something urgent about what that technology is actually doing to us. What *I/Eye* tells me is that something new is happening to my body. It is becoming quite sensitive to immaterial, invisible things, presences, substances. There is a kind of almost palpable aura to the extensions of the body by technologies. Spinhoven is providing us with one single, powerful image, one that allows us to reposition ourselves to appreciate with renewed awareness our enlarged dimensions. It may seem odd that people have never paid much attention to the physical sensation that results when one knows that one's movements are followed

by a camera, something you have already experienced in any security-conscious department store. All the installations in *Press/Enter* show different aspects of ourselves as members of our new electronic and computerized and networked environment.

The point and purpose of art dealing with technology is indeed to bring out not the literal meaning of the technology in question but its much deeper metaphorical value. The works tend to ask questions rather than give answers. Because they are often inter-active, they challenge us to participate somehow and get caught in the act, so to speak, of answering a question we had failed to hear. To the artist, the questions are, How close is this thing to me? How intimate is this relationship? What consequences are there to how I position myself in space? Am I really touching this per-son? What is touch anyway?

For example, technology allows people to hold hands and caress each other – at least through the mediation of our images – by videoconferencing, even if they are miles apart. To a business person, videoconferencing is a chance to increase the number of meetings while reducing the cost of transportation without losing too much of the quality of real presence. But for an artist, the same medium is a paradox. Paul Sermon's *Telematic Dreaming* (1993) proposes to us the paradox of a live, real-time telepresence, not as a tool for communication but as a tool for perception. In his installation, two people meet on the screen in the same "virtual space." The set-up of *Telematic Dreaming* is fairly simple, using "off-the-shelf" technologies, videoconferencing, and video projec-tors using a standard technique of image-editing called "chroma-key" function. You might say that most people would feel slightly embarrassed to even think about the erotic possilities of such a set-up. The paradox is that it is impossible to deny a real sense of

touch in the experience because it is happening in real time, with both people fully aware of their movements. But it is also impossible to say that they are holding hands because they are not really holding anything. Although there are already people who get "married" in virtual reality (an event celebrated at the last *Imagina* in Monte Carlo, on February 3, 1994), we are still deeply disturbed by the new possibilities of experience afforded by such technologies.

Until now, the images of ourselves that we carry in our minds have tended to be private and quite urbane. They have been shaped for us by artists, painters, novelists, dramatists since the Renaissance, and the invention of the printing press. Something like a civilized and personal interiority has been nourished by readers sharing a common understanding of the publicness of space and the privacy of mind. We still like this mental shape. We think it is innate, hence eternal.

A totally new variety of mind is now developing very quickly. It is collective, it is public, it is technically assisted. It is extremely fast and it is starving for a better understanding of itself. As the technological civilization delegates more and more mental responsibilities to machines, we need a much better idea of who we are and what we are like. We carry obsolete collective opinions and attitudes as if they were permanent fixtures of reality. The reason why artists address technology now is that they are taking charge of building and proposing more appropriate images of ourselves and the world.

A "Volcanic" Theory of Art

The contents of the earth, under a crust of hardened sediments, are churning away in intense heat. Everything molten roils about, heaving and pushing at the closed ceilings of a thin upper crust. Likewise, under the surface of our mental habits and our manners, new forms of language and experience churn away in the recesses of our innumerable brain connections henceforth extended to the surface of the planet via wire and wireless communications.

Imagine that under the surface of what you think and feel, something entirely different is going on. The ground of our opinions and attitudes is changing a lot faster than they are. The way we live with our bodies in cars, planes, and now sitting in front of computers is changing at breakneck speed, while our minds lag behind. When we are not jet-lagged, we are quite simply "culture-lagged." In much larger patterns of social activity, as well as in the smallest molecular adjustments at the core of our physical organisms, the changes that we are undergoing are not immediately perceptible, but the change goes ahead anyway.

A volcanic theory of art is based on the idea that art, as a product of collective unconsciousness, erupts at the surface of consciousness when the crust of reality is too weak to support the status quo. Why does the so-called crust of reality become weak? Because, fundamentally, our perception of reality is technology-dependent and changes every time new technologies invade it. A worldview based on print is challenged and weakened by the appearance of television, just as a worldview based on broadcast television is threatened by computer networks. Reality is indeed a form of consensus supported not only by the goodwill and the language of the communities that share it, but also framed and maintained by the principal media of communication used by that culture. Art erupts when a new technology challenges the status quo, also known as the State, or the state of things now.

Indeed, technologies invade reality with little or no conscious resistance on the part of those who readily adopt them. We accept cars, television, and computers in our lives, not always uncritically, but often without observing that each one of these time- and space-consuming devices is going to make a large dint, not only in our wallets but more precisely in our psyches. Each technological extension that we allow in our lives behaves like a kind of phantom limb, never quite integrated into our body or mind functions but never really out of our psychological make-up either. Take a look at the modernist bungalow defaced by a monumental garage. It is the architectural image of our bloated consumer culture, and also of our psychological build-up. Just to make room for one's car in one's home is to deface that place. To allow that car into our lifeform, our total being, is to weigh it down, to load it with a road map, a landscape of asphalt and city suburbs with gasoline advertising and carbon dioxide. Who would deny that we identify so much with our automobiles that we might as well wear them.

Current artists question the effects of the latest technologies such as computers, interactive systems, multimedia, virtual reality, and any other device on the marketable horizon not in a naively political way but at a deeper psycho-sensorial level. Who are we? What are these machines doing to us? What reflections do they give of ourselves? How are they transforming our own images of who we still think we are? The first products of such earnest questions encounter stiff disapproval and resistance from the art establishment as well as from the art public. The case in point here is Stelarc, the Australian artist who came to Toronto in the early 1980s to hang himself from the ceiling of a gallery by a hundred hooks planted in his skin. The horror of this sight aroused in some people the kind of fear and loathing that fire and brimstone pouring out of the mouth of the volcano would awaken.

Today, Stelarc is working on how the human skin is being extended by robots and electrical currents within and without the body. Stelarc is one of the first cyborg artists – that is, one who blends organic and technological properties within the human body. What he is saying is still not pleasant, but it is consistent with his work-in-progress and it carries the investigation of our uneasy bionic relationship with machines a step further. What is unpleasant about this kind of work is that it strikes so close to home. Of course, what Stelarc and many interactive artists have understood already is that what is in question in technology today is its relationship to the two most intimate parts of our being – our mind via all the computerized extensions of language, and our flesh via all the technological extensions of our skin and our limbs. To say nothing, of course, about the kind of further change held in store by genetic engineering and nanotechnologies.

At a second stage of the volcanic eruption, when the overflowing lava begins to cool off and go down the slope of culture, critics take over. The more astute among them point out the values implicit in the new work, and innovative, courageous galleries take a chance on enigmatic pieces, scoriae, molten lava still hot from the spring. Art partons walk around the piece, not always comprehending. Artworks take on better definition, more precise features, as they are held up to professional criticism. Their reputation grows accordingly and seeps into more popular forms.

This is the third stage, when cooling and sloping even more, reaching the base of the volcano, so to speak, the outpouring of new ideas and new forms is absorbed and transformed into existing social currents, enriching the outlying vegetation, and reaching large numbers of people. This process is truer now than ever, and it requires that at some point we extend the notion of art to

popular culture genres, not necessarily to make them indistinguishable, but to recognize that both serve – at different levels, with differing orders of penetration – the same vital function of updating the culture. Popular music, for example, has done more to grant a model of unification across vastly different cultures on the planet than any political program ever could. Rudolph Valentino yesterday, Michael Jackson and Madonna today are equivalents to Michelangelo for the masses. They have helped to reshape sensibilities very quickly. Popular culture is no more than the response of art when it is required to work a lot faster. Art now has to share with popular culture the responsibility of keeping us up-to-date.

In slower times, public art would do the job to get the less educated members of the population up to speed. Public art and monuments represent the last stage of the volcanic process, the total cooling, the weighty sedimentation of the establishment: it is the very function of memory, the museum, the institution. Of course there is no intention of reverse elitism in this hierarchization of processes: the sediment is just as important as the spark, if we want coherence and meaning in culture. The issue is not to brand and label the product but to observe the process of art in response to technology.

Thus art is part of the collective dreamwork that restores equilibrium to a time-shattered culture. Artists have been around to work the meanings of these things out and gradually inform and inspire the makers of popular forms. Indeed, one of the jobs of the artist is to provide us with a pattern of integration that can help us interpret the human dimensions – that is, the consequences on real people of being jumbled up in permanent time-lag. Art does not always succeed in redressing the lost balance, but it always tries to give a shape and a meaning to the culture thus disrupted.

For example, Italian Futurism and Modernism in sculpture, architecture, and painting in the late 1800s and early 1900s accompanied and supported the biases of the industrial revolution that had disrupted the slower rhythms of the agrarian culture. The art of Marinetti, Boccioni, Léger, and others attempted to give new, aggressive values based on the craft of Vulcan. This trend led to World War I, a further and more radical effect of technological acceleration. In terms of social adaptation to technological disruption, the volcanic alternative to art and popular culture is revolution and war.

This issue of acceleration is paramount. Mass culture has brought new needs, new spreads, new speeds to the production and distribution of images for popular consumption. In a stable culture, where technological turnover is slow, it is the State that supports and controls culture. The Golden Ages of Pericles in Greece or of the Sun King in France correspond to periods of techno-cultural stabilization when there is the beginning of a fit between social consciousness, communication infrastructures, and State control. In our own time, technological revolutions happen too fast to reach a mature stage. When technological innovation accelerates, the market forces take over.

At very high speeds, it is the technology itself that controls the market, and hence the culture. The task of collective harmonization and psycho-sensorial education is given to marketing the domestic technologies themselves. Seega and Nintendo are in the process of updating very quickly the reaction time of our kids' central nervous systems to ready them for instant familiarity with computers and networked communications. Right now Nintendo is tuning the nervous system of generations exposed more frequently to computer than to television screens. For a time, our kids

are turned into the hapless extensions of their Nintendo, as if they were complex organic servo-mechanisms of rather crude joysticks and digital video cartoons. That's another image of our new selves growing up. With virtual reality online just around the corner, we need more than ever every opportunity – such as *Press/Enter* – to interpret the effects of technologies on us. There used to be a time when history was reality; today reality is in great danger of becoming history.

A Distributed Growth Pattern

The art establishment has long resisted or played down connections with the artists who introduced machines among the traditional genres. The Venice *Biennale*, since 1986 and the last *dokumenta* exhibit in Kassel (1992), a quadriennial worldwide reference in terms of the established art market, were among the first among major art market exhibits to show, though very timidly, some technology in the art installations. The fact that Nam June Paik, one of the world's pioneers in video, was finally given his due by obtaining the first prize at the 1994 Venice *Biennale* is a long-awaited recognition that technology, albeit one as already established as video, is now "in." It will surely give a signal to the art community at large.

There are many problems with the new artforms because they are difficult to package, both conceptually and physically. They often escape all categories, except recent and rather loose ones such "installation" or "performance." That is a problem for the granting agencies when they are confronted with a project description. They don't know which budget to tap. There are even more problems for critics who, though they feel that unquestionably something is

really happening there, just don't know how to go about comment-
ing on things like that. The ground is unknown, the vocabulary is
still tentative, and the esthetic criteria are still under investigation.

So it is largely with accidental support and obscure determi-
nation on the part of the artists themselves that technological art
has developed exponentially since the late 1960s. It is hard to define
a place and a time for its beginning, but perhaps the 1967 New
York exhibit of EAT (Experiments in Art and Technology) could
be a starting point, at least from the point of view of naming the
connection for a large audience. Different foyers somehow lit up
in different places, at different times, but always connected by the
recognition of a common area of investigation. Inspired by the
pioneering work of Nam June Paik in video, the French artist Fred
Forest along with Hervé Fisher, the founder of Montreal's cele-
brated *Images du Futur* annual exhibition, would create *art soci-
ologique*, a rather silly name for a noble purpose, that of making
people become aware of what their media are doing to them. One
artist, now recognized as one of the pioneers of interactive art,
Myron Krueger, was already working then at what would become
one of today's most hotly contested area, the dematerialization
and virtualization of much of our experience.

Canada has been in the vanguard from the start. In Vancouver,
there was the Western Front in the early 1970s. The creation of the
Banff Centre for the Arts gave Canada an international profile that
was, at the beginning, predictably not fully understood at home.
During the same early years, sharing his time between Toronto
and New York, Michael Snow would address media and represen-
tation technologies head-on and inspire a change in focus among
many following artists. By becoming the head of the Ontario
College of Art, the British artist Roy Ascott would start a new line

of investigation in technology. His intentions were not well understood, and Ascott eventually had to leave to pursue a high-level career in Europe, but he had planted a seed that is still growing in Ontario.

Also at OCA, Richard Hill was the founder of the Photo/Electric Arts Foundation, and professor to some of today's most celebrated Canadian artists in technology – for example, Douglas Back, Norman White, and David Rokeby. Hill also created and ran one of the earliest series of annual conferences to examine the social and cultural implications of the computer (*Computer Culture*, Toronto, 1979, 1980, 1981). Artist-run centres, such as ARC (Art Resources Centre), A Space, and Art Metropole, as well as galleries such as YYZ, the Interference gallery, and The Power Plant would keep encouraging projects often refused elsewhere in Canada but eagerly attended in Europe and Japan. The McLuhan Program itself has been supporting theoretical and practical work in art and technology since the early 1980s. Between 1985 and 1989, whenever there was an art-and-technology-related event happening outside Canada, you could be sure to find that the Canadian artists numbered between 15 and 20 per cent of the total participation. Today still, there are more Canadian artists per capita than from any other country among the art users of the World Wide Web on Internet. The first important Canadian exhibit of art and technology was *The Artist As a Young Machine* in 1984, at the Ontario Science Centre. It was organized by Catherine Richards, and it would alert much larger audiences about the rapid technologisation of their lives. Recently (September 1994 – January 1995), another exhibit at the Ontario Science Centre, *Techno-Art*, updated visitors on developments over the ten-year period since the first.

Art-and-technology yearly conferences, although at first attracting only a handful of participants, created a continuous network of artists across the whole world, in Italy (*ArtMedia* in Salerno and Naples, 1985, 1986, 1987 and later), in Austria, (*Ars Electronica*, Linz, annual since 1979), in Japan, (*Artec*, Nagoya, since 1987), in Spain (*Art Futura*, Barcelona and Madrid, since 1989), and also in France (*Imagina*, Monte Carlo, 1980–95 and Rennes, *Festival des arts électroniques* [1987–89]). In France, two critically important exhibits would mark the 1980s, one in 1984, *Electra* at the Musée d'Art Moderne de la Ville de Paris, and the other, in 1985, *Les Immatériaux*, located in the enigmatically technological Palais Beaubourg (now known as the Centre Georges Pompidou).

Things began to pick up speed during the late 1980s, when some serious funding came the way of artists who until then were only struggling to make ends meet, even as they were developing rather stunning work with derisively modest equipment. In Europe, a few German cities decided to invest in art-and-technology research institutions (Cologne, Frankfurt, Karlsruhe). The German example shows that where there is a will there is a way: in five quick years, the German artists in technology and many foreign artists invited into their new schools moved forward to the cutting edge. In Japan, too, several research centres supported by Canon (ArtLab), NTT (P3), NEC (InterCommunication Centre), Toyota (*Artec*), have allowed Japanese artists to appear in growing numbers, showing extremely original work in areas where there was no show only a few years ago. In the U.S. the biggest trade show for computer and graphic design tools, SIGGRAPH, decided to add a small art section on the side in 1987.

There is now a new set of movable conferences such as ISEA, the International Symposium of Electronic Arts, the first of which

was held in 1990 in Rotterdam, and the latest is planned for the fall of 1995 in Montreal. People are cropping up from everywhere to work on these matters. At the last ISEA meeting in Helsinki, there were more than four hundred people, many among them artists who had to pay their own way on budgets too well known to comment on. The commitment is very strong, like a real calling.

ISEA '94 was especially critical for me because there I realized that the space of the planet had ceased to be a neutral void. It was now alive with hundreds of like minds all connected internationally by a single chatty network, the Internet. And the people whom I encountered at ISEA were together constituting a new form of mind. For those few days in August, Helsinki had become one of the world's points of convergence and recognition of a new way of seeing ourselves. The art-and-technology scene is not yet a market, but it is an emerging process. It erupts here and there and connects more like an undercurrent than an underground. It is volcanic.

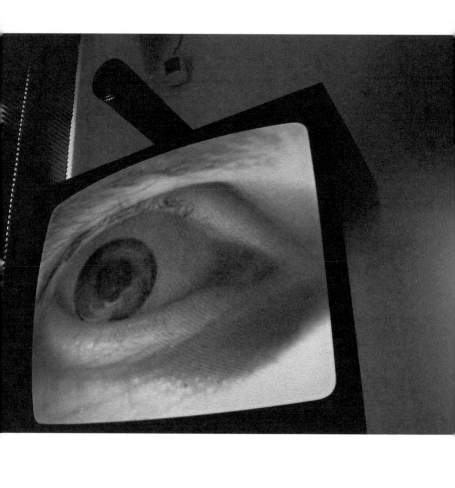

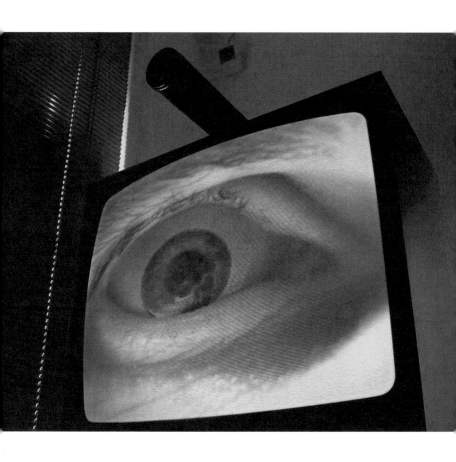

LEFT AND ABOVE
Bill Spinhoven
I/Eye 1993
Various phases of the work as it
follows the viewer through the space.
Photo: Courtesy of MonteVideo Time-
Based Arts, Amsterdam

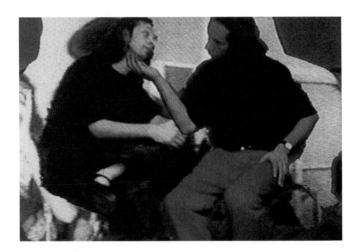

Paul Sermon
Telematic Vision 1993 (Detail)
An interactive installation that allows
two geographically separated participants
to interact through teleconferencing.
Photo: Courtesy of the artist
(Not in exhibition)

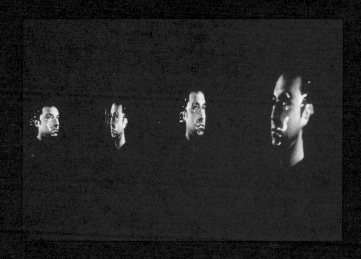

Catherine Ikam
Love Story 1995 (Detail)
Four views of cybernetic beings.
Photo: Courtesy of the artist

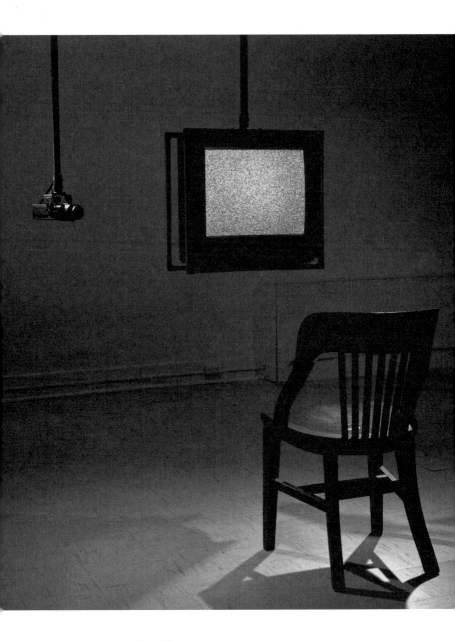

George Bures Miller
Conversation/Interrogation 1991 (Detail)
Photo: Courtesy of the artist

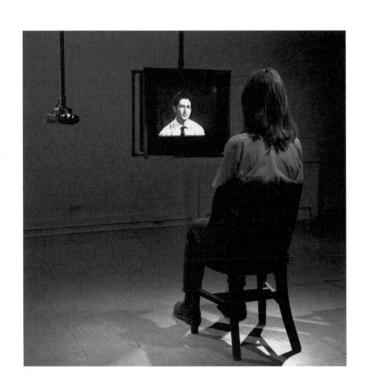

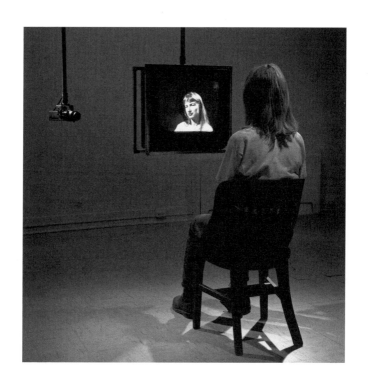

George Bures Miller
Conversation/Interrogation 1991 (Details)
In this work, a viewer's image is picked up by
a surveillance camera and integrated into the
video image, creating a "staged" conversation.
Photo: Courtesy of the artist

FIGURATION AND INTIMACY
IN ELECTRONIC MEDIA

John Massey, Jim Campbell, and Julia Scher

Robert R. Riley

Press/Enter provides an opportunity to look at new forms of elec-
tronic art, interactive video, and computer-assisted projects, to
observe them in light of the rapid development of image-making
technologies available to visual artists, and to consider the value
of media art to contemporary audiences. What we call today the
Telecommunication Revolution has a direct and provocative cor-
relation to many of the claims and excesses of multimedia design
typically associated with the 1960s, and to other antecedents in
the vision of a pioneering generation of artists who originally
explored electronic media as a visual art form.

 A reflection of the emergent media environment of that era,
communication networks were once envisioned as the future in
the sense-surround of large-scale multiple-screen projections pro-
duced by the corporate-sponsored pavilions of the World's Fairs –
Expo 67 in Montreal and in Osaka, 1970. The pavilions, such as
those sponsored by Bell Labs and PepsiCo, engaged groups of artists
and engineers who collaborated with the communication indus-
tries on creations of visual and aural phenomena, narrowcasts,
and multiple-screen projections. Splendid in many aspects of pro-
duction, the engaging visual effects and big motion pictures
served an instructive function quite outside the bounds of artistic
experimentation as models for audience interaction with media.

As a platform for the introduction of new ideas in urbanism, design, and communication since the 1933 *Century of Progress* in Chicago and the 1937 exposition *World of Tomorrow* in New York, the World's Fairs were appreciated as the places where the concept of the future was formed and consumer-related appliances were introduced. At subsequent World's Fairs, well-crafted multimedia exhibitions put celebratory form and pageantry to the display of technological power, thereby advancing electronic design, computer sciences and the development of computer programs, image synthesis in video and television, as well as new forms of filmmaking and the manufacture of new tools and materials as utility and entertainment.

The capacity of new communication technologies to attract, amuse, and dazzle was paramount. If nothing more, multi-image projections filled vast amounts of space with an innovative syntactical organization of visual information and, as such, encouraged the viewer to expect nothing more from the experience than to witness the pleasure of technological domination, escape the boundaries of the self through visual excess, and dissolve into the environment.

At the same time, a small group of independent artists and collectives such as EAT (Experiments in Art and Technology) explored

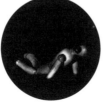
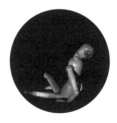

#1 Jack wakes #2 Jack wakes #3 Jack wakes

alternatives to the commercial applications of technology and created discreet forms of visual and kinetic art. Rather than the spectacular commodity it appeared in its World's Fair counterpart, an expressive and utopian potential of technology as a medium was discussed and theorized about. Using much of the same technology as display and communication industries, artists thought critically about the media's influence on cognition and perception of time. Immediacy was identified by both schools as an inherent and significant quality of their research, and alone it forms media's most prescient message – now.

Artists such as Stan Vanderbeek, Nam June Paik, Aldo Tambellini, and others looked imaginatively at the apparatus of television and its function, setting the cornerstone for explorations of video as an artist's medium: Electricity is the muscle, electronics the nerve was their axiom. Their work not only referred to traditions in painting, photography, and film that extended pictorial representation into the electronic medium, but to the machine itself.

Multimedia, closed-circuit video matrix installations and projections were developed by artists who looked at the hardware of television as a new "ready-made" and the electronic signal as the pure language of the medium. Their "electromedia theatre" of the

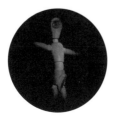

#4 Jack stands #5 Jack stands #6 Jack is startled

1960s inspired a short-lived utopia of modernist reform and analysis that was quickly absorbed by the communication industry of television as innovation and style.

The large-scale industrial display and its alternative, philosophical exploration of a new artist's medium – though opposed in principle – are the two areas of exploration that form the rich pretext for the consideration of contemporary practices in video, television, and related artists' media seen in this exhibition. Working in various disciplines and applications of the installation genre, John Massey, Jim Campbell, and Julia Scher draw on modest technological resources to form particularly insightful expressions of the influences of media on vision and the imagination. These artists' investigations of the matter and material of media are similar to those of generations before, whose visionary work, theory, and criticality set precedents.

John Massey's arcade of thirty-five images, *The Jack Photographs* (1992–95), to be seen in sequence at a slow, walking speed, is an introspective reflection of technological influence. Framed in circular mats that fluctuate in diameter from large to small to mimic the eye's dilation and constriction in response to psychological states, a wooden model of the human figure is shown manipulated into expressive positions. Its streamlined, mechanical form is com-

#7 Jack feels

#8 Jack feels

#9 Jack feels

116

plicated by human anatomy, inserted through computer animation processes and rendered in detail.

Acting as a screen for the projection of these anatomical parts, the wooden model is both animated and disfigured. Massey's process touches consciousness and reveals his scepticism: through highlights and shadows in photographic exposures, reflections in dark spaces and shiny surfaces, the images refer to the dialectical mind/body conflicts and to their own tools of construction. The inevitability of technology to maim the senses and privilege vision as the dominant sense preceptor at the expense of all others is here poignantly expressed. For Massey, the computer is also the puppet. It is not just the mannequin but the computer as well that represents an agent external to the self that may enact our wishes. Massey's interrelated images of flesh and wood, sensory organs and mechanical joints in *The Jack Photographs* suggest to the viewer that the body is the site of perception and memory, not the mind alone.

For Massey, the notion of watching or looking at something is also an exercise in self-perception and forms another meaningful ellipsis to *The Jack Photographs*. The question of self-perception, how the tools of observation intercede, and how the mind works its anxious response, its motivations, and its insights are each

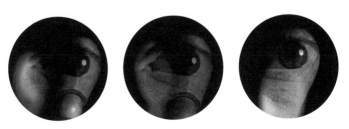

#13 Jack touches #14 Jack touches #15 Jack touches

puzzling experiences and difficult to explain but perhaps, in electronic art, possible. The visual codes Massey embeds in this artwork are an encryption that underscores the effects of working with photography in combination with other technological media. Jack is the foil through which the artist engages perception as subject, identity or self-awareness as object, and the structure of vision as content. The camera and computer processing – or the substitution of the viewer for the camera in these works – create a fascinating script for the reality they portray.

The promise of interactive technology in communication predicts that the individual will have boundless access to information. The organization of such claims, like the earlier multimedia projects of the World's Fairs, explores the potential of the delivery system, not the quality or content of the material delivered. The maximal programming the technology can generate is often the primary criterion for success, and distribution is valued over data. Julia Scher's *Predictive Engineering* (1993) investigates the material of data services, surveillance, and interactive video, just as Massey's digitally reanimated Jack observes the viewer and observes its own predicament encircled and confined as subject.

Developments in the communication industries characterize our times but without artists' intervention lend little meaning to

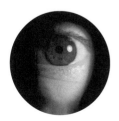

#16 Jack touches #17 Jack glances #18 Jack looks

them. Scher examines media and communication systems for flaws and understands them as life-altering technologies, not just as the neutral facts of modern life. In *Predictive Engineering*, Scher's surveillance installation engages the art gallery itself as a panoptic experience, a site of social interaction and suggests through the naked, unadorned apparatus an occupied territory. Through the installation, the artist conveys her concerns regarding how behaviour is monitored and how identification in video imagery is regulated, duplicitous, and ominous. The means of information distribution as the artist's medium is not new to the twentieth century: Scher's practices frame the televisual systems of identification for contemplation of its methods and seek to antagonize or shatter its control. It is in the media that values are reflected and practices of definition converge. It is in technology, particularly video surveillance, that public memory is structured, rarely stored, and in its transposition of fact and fiction held accountable.

Whereas Massey's Jack is groundless and floats in a black hole, both Scher and Jim Campbell combine video and electronics onsite to take, as location, the art gallery itself as well as the viewer as their subjects. *Digital Watch* (1991), *Memory/Recollection* (1990), and *Untitled (for Heisenberg)* (1994–95) by Campbell invite speculation

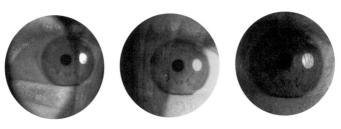

#19 Jack touches *#20 Jack touches* *#21 Jack looks*

on reality and fantasy. The interchangeabilty of large and small scale through pictorial and technological apparatuses, and the differences in analog and digital languages converge in single artworks. Evoking time in sequential arrangements and actually using the clock face, its hour integers and sweep hand in combination, live video cameras make a record of time and incident, and with digital frame delay organize the flow of time into sets of still images and fluid motion.

Lived experience is momentarilty suspended for reflection in Campbell's work. It invites speculation on the issues of objectivity and subjectivity in media-based art. In *Memory Recollection* (1990), images are stored as still frames on videodisks, which are programmed by the artist to hold an array of snapshot images. The images appear and electronically decay as they pass from one screen to the next in a left-to-right sequence, making an interactive record of the sight and the viewer. Campbell creates in video a visual model of the beguiling influences electronic communication has on the senses. His five-video-monitor matrix has collected images since its fabrication in the studio through each exhibition at various locations nationwide, and at its current site. The mechanism continues to create its own history and collect new data as an

#22 Jack looks ahead #23 #24

electronic and real-time medium in which perceptual dynamics and the stability or objectivity of the video frame are explored.

Untitled (for Heisenberg), made for *Press/Enter*, invites the viewer to interact with live cameras and a projected image tableau made to honor the Heisenberg Uncertainty Principle, a theory that challenges the accuracy of any unit of measure and the impact of physical conditions on measurement. Assuming its relevance to the determination of meaning in art, Campbell evokes the theory in the creation of an artwork about attraction. With this installation, the artist makes a visual expression of uncertainty: in the approach to understand a situation, the viewer actually causes it to change.

Through such fugitive imagery and original electronic systems, these three artists engage the viewer in the puzzle of meaning. The installations invent contexts for the concerns of artists who address the pervasive media environment and provide for the contemporary audience its effects and its influences through its application in works of art. Furthermore, the artworks themselves engage the viewers in critical equations of image and environment, which assist in the formation of a critical text; we are reminded that the future is a construction site, and it is anticipated by these artworks as new models of or reflections on experience that may provide significantly different blueprints for progress.

#25

#26

#27

#28 Jack wakes

ABOVE
John Massey
The Jack Photographs (nos. 1–22) 1992–93
Installation view at the Art Gallery of Hamilton.
Photo: Courtesy of the artist

LEFT FROM PAGE 114
John Massey
The Jack Photographs (nos. 1–9, 13–28) 1992–93
Photo: Courtesy of the artist

ABOVE
Julia Scher
Predictive Engineering 1993
Installation views at the San Francisco Museum of Modern
Art. This interactive work catches the viewer's image and
recontextualizes it through a variety of means and devices
through both a real and fictionalized context.
Photo: Charles Erickson

RIGHT
Julia Scher
Predictive Engineering 1993 (Details)
Photo: Courtesy of the artist

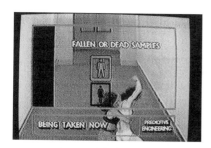

FALLEN OR DEAD SAMPLES

BEING TAKEN NOW

PREDICTIVE ENGINEERING

36A
24AA
3BB

▽ holding
▽
▽ holding
▽
▽ surprise, the social sabotage car is outside
▽

DANGER: "WE" VS "THEY" IDENTITY STUD IMPLANTS ARE BEING ACTIVATED... NOW/

▽ List I feel... Awkward
▽ Hey, monitor 4 on the 4th floor is missing
▽
▽
▽ I'm turning on the sex checker
▽
▽ There's something wrong with the program

WARNING: YOU HAVE ENTERED A CLOSED CIRCUIT TELEVISION MONITORING AREA

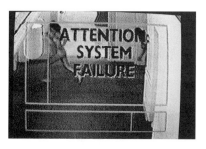

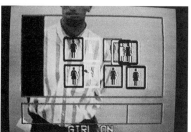

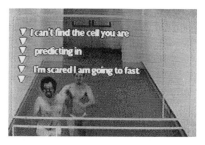

LEFT AND ABOVE
Julia Scher
Predictive Engineering 1993 (Details)
Photo: Courtesy of the artist

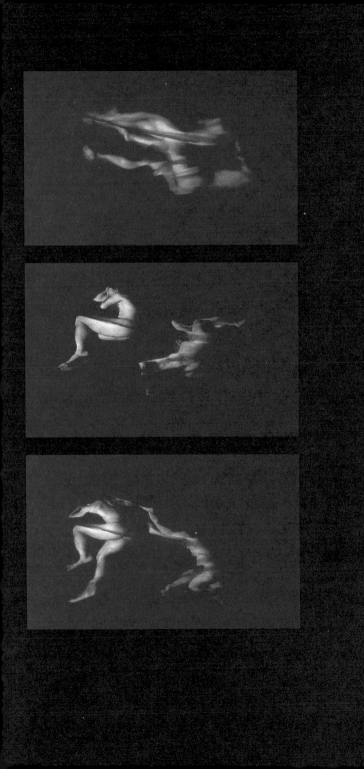

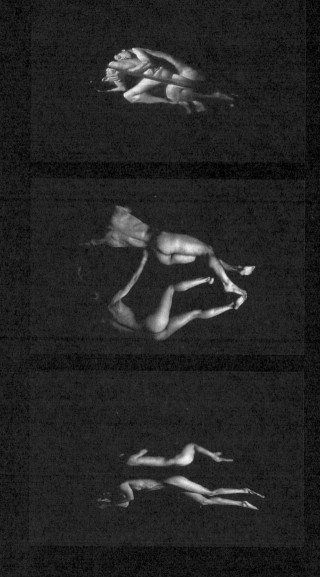

LEFT AND ABOVE
Jim Campbell
Untitled (for Heisenberg) 1994–95 (Details)
An interactive work in which the viewer's image is
transposed into the space of the couple on the bed.
Photo: Courtesy of the artist

NEURAL GAMES:
REMAPPING THE LOCUS
OF DESIRE

Allucquère Rosanne Stone

Architectural Space and Emergent Self

I spend my days in the not unpleasant task of roamin' through the electro-gloamin' on the lookout for new kinds of space. As architects will tell you, consciousness and space are closely tied. Space has a conditioning effect on consciousness; the kind of space we occupy is a powerful determinant of mood and sense of self. Architecture theory and many architects in general are deeply involved with the difficult and challenging prospects of figuring out how cyberspace conditions consciousness ... a set of questions including things like this: since architecture is partly about shelter and privacy, what does architecture mean, really, when there's no weather and you can be invisible at will?

That's one set of questions, anyway. The most intriguing, of course, is how architecture elicits deep experiences, profound states of consciousness. What's the virtual equivalent of Chartres? Of the Rothko Chapel? (Or, for that matter, of the Westin Peachtree Plaza in Atlanta, where I sit writing this – an environment that conveys the unsettling impression that one is already in a weird cyberspace. You gotta see it to understand.)

Space and its modulation in the forms of architecture also condition community. People act differently towards each other and in relation to the idea of community, depending on the environment in which they find themselves. I and a few crazy friends

think that this situation is one of the most intriguing, not to mention promising, characteristics of cyberspace and its myriad instantiations as virtual environments.

All cyberspace environments produce forms of community (even irc #hottub, in its happily brainless way), but not all of them are what I'd call transformative. Whoa, let me make a distinction here before you start reaching for your pen and writing me outraged letters. In McLuhan's sense, cyberspace itself is transformative, and that includes #hottub. I agree. But let's face it, sometimes I put on my bourgeois, snobbish hat and start looking for things that make me consciously feel as if I've spent the night inside Chartres.

> 9 "Eventually, any location you designate becomes a focus for heightened erotic sensation. The intensity of the heightening easily includes, but is not limited to, orgasm. Of course orgasm is not the purpose of the exercise...."

I have stakes in the cybermensch. The stakes are simple – life is short; novelty can offer the chance for growth; we might change things for the better, whatever that means, by enabling new sorts of subjectivities, new creatures. Paul the apostle thought doctrines of faith and redemption would do just that; he used the words *kaine ktisis* – new creature – to describe the output of the redemption-system. My work isn't about faith or redemption, but it sure as hell is about new creatures. I mean the creatures we might become, will become, are becoming.

Okay, then, enough of the portentous intro; I've fulfilled my daily requirement for the serious-voiced *Shape of Things to Come* – type announcer who informs us in sepulchral tones about the Future of Humanity.

So let's talk about sex.

Sooner or later, almost everybody has sex in cyberspace. It's no more ubiquitous there than here in RL, but as soon as new arrivals figure out that the Thought Police are off on vacation, they generally start peering around with a certain lust and maybe even a gratifying sense of avarice. Why am I interested in sex? First, because I'm human; second, because I find some of the most refreshing work in mental aerobics being done by performance artists like Annie Sprinkle, Kate Bornstein, Susie Bright ... nasty women whose themes are specifically those of sexuality, gender, desire, and disrupting conventional modes of thought. They have deeper agendas, and I needn't bore you by spinning them out at length, beyond mentioning (just in case you forgot) that sex and sexuality – and the attempt by politically conservative forces to tightly link sexuality to reproduction – are hotly contested battle zones of social control and personal identity.

It's not clear yet whether changes in personal style and outlook in cyberspace imply corresponding changes in RL. If new spaces create conditions in which new creatures can emerge, are those creatures then restricted to live only within those spaces? Or are they empowered to cross boundaries, to visit and perhaps to infect other spaces? Do they carry within themselves, like viruses, transformative epistemes? I decided to find out. Or, at the least, to get some idea of what might happen if those boundaries between worlds were breached.

I started by considering sensuality, in the context of erotics. The thing that has fascinated many of us since the possibility of virtual worlds first loomed on our epistemic horizon has been desire and the erotic sensibilities. We usually express this constellation of symbols and performances in simpler terms as sex,

and in fact cybersex has become one of the more bizarre of cynosures, particularly among artists – who, I think, are able to treat the idea of virtual erotics with the irony it deserves. Not that cybersex wouldn't be fun, if it existed; or, perhaps less ironically, if it were sufficiently worked out. If you've been following the debates over virtual reality these past few years, you've already noticed that the promise of VR vastly exceeds the fulfilment, and is likely to continue doing so for quite some time ... particularly in the most hotly (as it were) discussed topic of virtual sex. But for anyone who has tried it, cybersex works much better as an art piece or ironic gedankenexperiment than it does as erotic practice. And yet the fascination continues. We are persistent creatures, hungry, lusty, greedy creatures ... more so, perhaps, in academe and the arts, though it is differently expressed in each of those disciplines ... and more power to us for being so.

> 7 "Redirecting energy is the most use
> ful tool. Like any skill, it improves with
> practice. Learn to move energy to spe
> cific places on the surface of your body.
> Practice increasing the sensitivity of
> selected areas...."

Nowhere quite so clearly as in cybersex do the various styles and performativities of Western erotic practices make themselves manifest in all their wonderful diversity. This appears to be because the simplest socially ingrained responses, the usual and customary dance of gender and erotics in its common bipolar manifestation, is the least likely to work in virtual environments. That is to say, we can't lie down on top of one another, or insert/surround anything into/with anything. Of course I add the qualifier "yet." What makes cybersex work are the principles of bandwidth and data compression, which I've written about elsewhere, because of the

way they deeply engage our imaginative faculties. By virtue of imagination, everything happens and nothing happens, all at the same time. Erotics get displaced from the physical to the imaginal; your cortex stops schmoozing with sensory input and starts partying with your thalamus.

But even if/when we reach the stage of full-blown mechanical gadgets that mediate cybersex, which is what the original teledildonics was about, even though it was only in fun – and, being endlessly inventive creatures, we almost certainly will reach that stage – we are still unconsciously buying in to a particular conception of how erotic experience maps onto the body's surfaces and interiorities. Ultimately, and particularly if one is male, comes a narrowing of focus, a zeroing-in on certain erotic areas. All of this inscribes and describes a body bounded by a constellation of cultural practices that we might characterize as modernist. The body thus enunciated and inscribed is already obsolete, has been so for some time, and you don't need me to tell you; there's not much argument about it among the artists I hang with. What has been lagging is the interpretation of this realization into electronic practice; or, when do we put our money where our mouse is?

Cookbook for the Postmechanical Body

Let's name the parts and describe them. What I'll call here the postmechanical body is the result of what's happened to our sense of our physical-being-in-time at the close of the mechanical age and the inception of the virtual or information age. The terms "virtual" and "information" aren't interchangeable, but for our purposes here let's assume that their meanings are alike enough that we can ignore the differences. (This is provisional.... I don't

want to hear from someone later that I've collapsed the two terms, okay?) As I discuss it here, the postmechanical body is the output of an abstract assemblage that processes our sense of self from an internal, neurologically mediated state to an external, spectacular state. My argument, if you can call it that, is that the body image, or sense of physical, topological self, is partly mediated by an internal hardwiring as well as by social conditioning. Throughout this essay I propose some ways of changing how the internal hardwiring of the neurobody maps onto the physical body's topology. My eventual aim, partly ironic, is to change the nature and character of erotic sensibility and play both within and without virtual space. The purpose of this is architectural, since the body is the citizen's primary habitation.

> 4 "Find places on the body that are slightly but not highly pleasurable. Cultivate them. Do nice things for them. Talk to them. Gradually move energy from other places to them. Notice how they expand and how their erotic sensibility deepens...."

Theorists of virtual space sometimes talk about the Body Without Organs, which was elaborated at length by Deleuze and Guattari. Some theorists argue that the cyberspacial body, because it is a symbolic assemblage without extension, is an instantiation of the Body Without Organs. The Critical Media Ensemble made a very nice case for this in *The Electronic Disturbance*. In contrast to the Body Without Organs, the postmechanical body has imploded/exploded into a vast congeries of organs, surfaces, protuberances and invaginations, enabling a myriad of somatic and aesthetic responses. The postmechanical body possesses multidimensional tactile extensionality, every surface of which is potentially an attractor and grounder for the play of sensuality.

Ultimately we have to get real – by which I mean that we stop talking and create some action. This maps back onto the original problem: erotics is ultimately grounded in and authorized by bodies. Somewhere there has to be a translator module, a practical interface that inputs erotic information to the network in the form of symbolic assemblages and outputs physical pleasure. I've had the opportunity to try out the first- and second-generation cybersex suits, and so far they don't seem to add much to the machineries of joy. The trouble with cybersex suits is that they are almost entirely symbolic – speaking in terms of physical practice, they aren't much of a good time, really. They do point out some interesting directions and possibilities, for some unknown time in the future.

My first job in this essay was to define the postmechanical body. The second is to describe what it's made of, its constituent simultaneous multiple bodies. Think of these as coexisting in space and time, perhaps in different dimensions, if that helps the visualization. In good ol' Enlightenment fashion, there are three of them – everything comes in triads, right – One: the neurobody, or internal neural impression of an external physical form; Two: something we'll call the translator module, which acts as a switchboard between neural impression and physical sensation; and Three: the topological body, or the physical body considered as a transmitting and receiving surface. I'm going to suggest how the translator module works, and think about ways of constructing one. This is interface theory at its most practical, its off-the-street-and-in-your-face reality. It's about remapping the locus of desire to extend an expanded and refigured erotic both virtually into the machine and physically into the body itself.

Correspondences between Somatics and Cyberenvironment

	Neurological (Bio-substrate)	Virtual (Symbolic substrate)
Foundation	*Body theory*	*Cyberspace theory*
Internal	Neurobody, body image	Code descriptors
Translator	Phantom-limb phenomenon	Interface
External	Topological body	Cybersomatic topology

First let's consider the neurobody – the subjective sensation of one's own physical form, its characteristic shape, which is continually generated by the nervous system even when stimulated by no particular sensory input. Medical research indicates that the neurobody is persistent in form, and observation teaches us that when our topological body is seriously altered, by disease, say, or accident, we are able to psychologically adapt to those changes. By such psychological adaptations the neurobody maintains a kind of mapping between itself and the reality of the topological body. The mapping is plastic; that is, as the topological body changes, the mapping to the neurobody (which doesn't change) also changes. This was first noticed by the early neurologists (e.g., Hughlings Jackson et al.), who called it the body image.

> 3 "Ground and center. This means that
> you must find a quiet place to do the
> work, close out distractions, and focus
> your attention on yourself. This in itself
> may be impossible. But if you achieve
> it, arrange to sit quietly in a comfort-
> able position. Breathe deeply and slowly.
> Come gradually to stillness. Take as
> much time as you need. The process may
> take several days or several weeks...."

The body image was something that Jackson observed in his first encounters with radically altered bodies (battle veterans), and in that circumstance it was perspicuous. Jackson was working at the time in the first hospital established specifically to deal with severe battle trauma, the so-called Stump Hospital in Philadelphia, opened during the United States Civil War. There Jackson had the opportunity to observe over long periods of time and in consistent circumstances the changes in soldiers' subjective body experiences after they had had limbs mangled, amputated, or blown off. In these grisly circumstances Jackson observed that soldiers' internal images of their bodies did not always change to match the new external reality: that frequently the internal body image retained the shape of the old, now vanished, body. Jackson noticed that the obduracy of the internal image was important to the man's mental health. When the soldiers were fitted with prosthetic limbs, the internal image infected the prostheses, too – expanded, and extended parts of itself to fill the prosthetic limbs and to imbue them with a kind of quasi life; and later to permit the wearer to psychologically recuperate them back into the somatic body and harmonize them with the neurobody. In practice this meant that the so-called phantom limb served a very practical function.

The phantom limb is an intriguing and complex phenomenon. Phantom limbs take many forms; they do not always mimic the shape and size of the absent member. Most commonly, however, they extend to fill the prosthesis. Many persons who wear prosthetic limbs find that they cannot operate them properly unless the phantom limb has emerged and filled the prosthesis. Frequently the phantom limb retracts into the body when the prosthesis is removed. Occasionally the phantom limb does not emerge to fill the prosthesis when it is put on, and in such circumstances wearers

develop strategies for coaxing the phantom out. The most common method is to lightly stroke or pat the stump, or to flick it with a finger, to "wake up" the phantom limb.

This is an intriguing recuperation of subjective body shape, and its translation into the extremely practical business of recuperating the physical body into a sensation of more "normal" envelope and character. The phantom-limb phenomenon mediates between the internal body image and the external functioning body, bringing them into alignment, into resonance, both symbolically and practically. I use it as an imperfect analogy to the kinds of translation devices I'm alluding to here.

> 1 "While visualizing your most powerful erotic image, gently stroke a pleasurable part of your body other than your usual erogenous areas. Let the sensation in that part spread to take in your whole body, including the areas from which you derive your deepest pleasure. Visualize them as extending toward each other, merging, becoming the same area. This new part is your most erotic place...."

In practice there is a critical point beyond which the mediation between neurobody and topological body breaks down. Jackson observed that in cases of extreme trauma, when large parts of a soldier's body had been destroyed, there was a point at which the disjunction between the internal body image and the external physical envelope became too great to be bridged. When that happened, the internal body image disintegrated, and along with it the man's personality – what we would call a psychotic break. Apparently an internal symbolic-somatic coherence is necessary to maintain a functioning sense of self.

I point this out because it relates directly to our work in articulating the postmechanical body. The body image and its breakdown are examples of complex correspondences and tensions between inner and outer somatics. Limbs have topological qualities of limbness; phantom limbs occupy the same physical space as the somatic structures whose neural resonances give rise to them. There is no reason, really, why this should be the case: a phantom limb might emerge anywhere. It is a symbol, mediated by an underlying neural matrix. In theory, it is a floating signifier. What ties it to specific topological loci is unknown.

I want to propose that we can mess with the simple one-to-one correspondence between internal body image and external somatic topology. The plugboard for this – the translator, the interface, if you will – is a constellation of exercises that train the neural matrix to remap such correspondences.

There is plenty of history for this. The techniques are in everyday use at physical rehabilitation centres. Some of these specialize in retraining persons who have become paraplegic or quadraplegic, and who consequently have no sensation in the areas customarily thought of as erogenous. Such persons learn to refocus their erogenetic sensibilities to areas of the body that possess sensation. So plastic is the body's sense of pleasure that retraining has a high success rate. Of course it doesn't hurt that pleasure is a strong attractor in our lives anyway; we can tap large reservoirs of energy to drive us towards it.

Cookbook for Remapping the Locus of Desire

I took the remapping training as an experiment, to see what it was like and to see what would happen if I did. I then extended it with exercises I developed specifically for the purpose of remapping the erotic areas of a properly functioning body. Although it is intended for the physically challenged, I adapted it to a baser purpose: communication prosthetics, a specific way to translate information into somatic sensation, symbol into physicality. It worked just fine. There's nothing special about my body; if I can do it, you can too. So let's get busy. There's a lot of sensation waiting to be experienced in fairly amazing ways.

Notes

My colleague and friend Brenda Laurel
first expressed the idea of the cortex
partying with the thalamus. Thanks to
Mysti Easterwood for informative dis-
cussions of the cybersoma; the term
is hers, although I have elaborated the
concept differently. Jeff Prothero pro-
vided invaluable help with verifying
the effects of neurophysical remap-
ping. This paper is meant to be no
more than a sketchy introduction to
the topic. Although my tone here is
playful and ironic, remapping does
work; I use it in my performance pieces,
where its effects can be more readily
demonstrated.

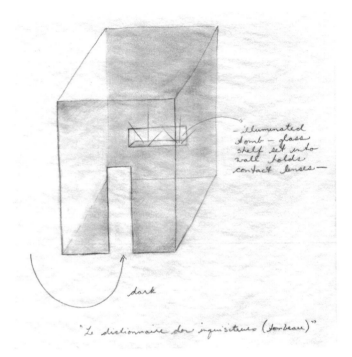

the following handwritten annotations appear on the drawing:

— illuminated tomb — glass shelf set into wall holds contact lenses —

dark

"Le dictionnaire des inquisiteurs (tombeau)"

TOLERANCE

TORTURE

IDOLATRIE

IGNORANCE

AIGUILLETTE

ALIENATION

PARJURE

PAYEN

SUPPLICE

SUSPENSION

SIGNE

SILENCE

CHOIX

CHRIST

SUSPECT

REBELLION

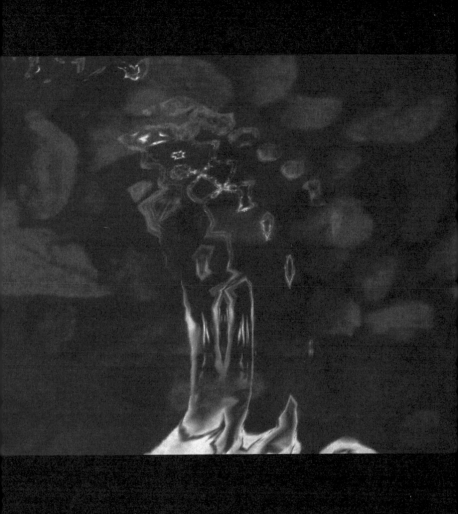

Monika Fleischmann
Liquid Views 1993
Photo: Courtesy of the artist

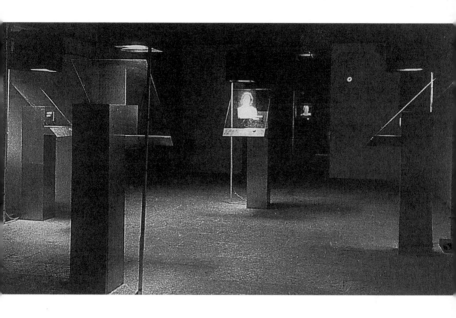

Luc Courchesne
Family Portrait: Encounter
with a Virtual Society 1993
An interactive installation work
allowing a dialogue to develop
between viewers and virtual beings.
Photo: Courtesy of the artist

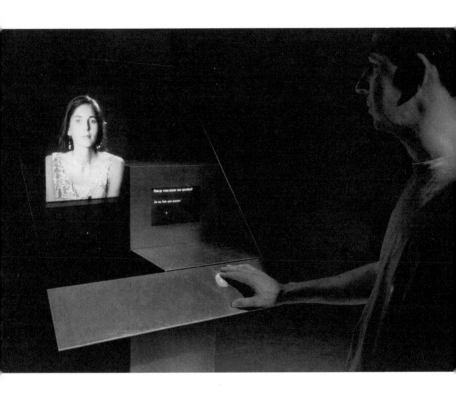

Luc Courchesne
*Family Portrait: Encounter with
a Virtual Society* 1993 (Detail)
Photo: Courtesy of the artist

Luc Courchesne
Family Portrait: Encounter with
a Virtual Society 1993 (Details)
Virtual beings.
Photo: Courtesy of the artist

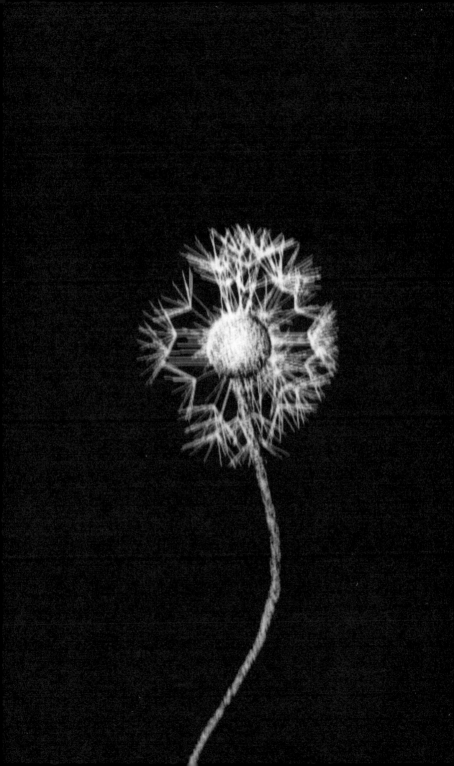

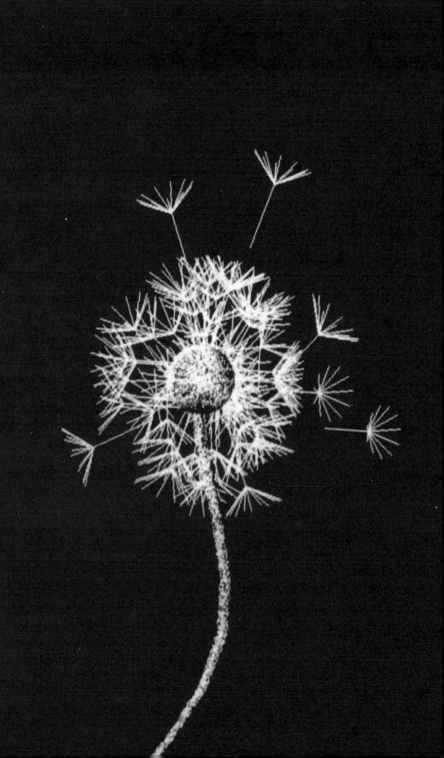

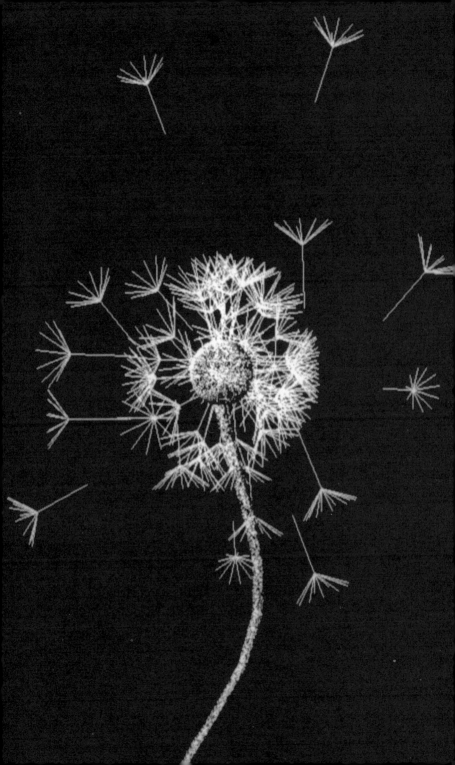

THE EXHIBITION

Sylvie Bélanger

The Silence of the Body 1994
interactive installation work
dimensions variable
black-and-white transparencies, two
colour video cameras, two colour mon-
itors, video projector, etched plexiglass,
fluorescent tubes, wood structures
covered with lead
Collection of the artist

Jim Campbell

Memory/Recollection 1990
interactive video installation work
dimensions variable
five small cathode-ray tubes, custom-
built electronics, small computer,
black-and-white video camera,
white pedestal
Collection of Richard and Roselyne
Swig, San Francisco

Digital Watch 1991
interactive installation work
dimensions variable
rear projection monitor, custom elec-
tronics, two black-and-white cameras,
pocket watch, shelf, black pedestal
Collection of the San Francisco
Museum of Modern Art, Doris and
Donald G. Fisher Fund

Untitled (for Heisenberg) 1994–95
interactive installation work
dimensions variable
custom electronics, four black-and-
white video cameras, two video-disk
players, computer, two amplifiers,
eight speakers, position detectors,
high light output video projector,
black pedestal, sand
Collection of the artist
The artist wishes to thank Dan Lutz,
Catrina Sdun, Rachel Strickland, and
Alexandra Tana, and the performers,
Patricia Jiron and Michael Meyers.

Edmond Couchot (software,
Michel Bret)
Je sème à tout vent (plume et
pissenlit) 1988, 1992
interactive installation work
dimensions variable
SGI Indy computer, software, sensor,
video projector, plexiglass, custom-built
pedestal for computer and monitor
Collection of the artist

Luc Courchesne
*Family Portrait: Encounter with
a Virtual Society* 1993
interactive installation work
dimensions variable
four aluminum tubes, eight aluminum
beams, twenty aluminum panels, four
glass sheets, four aluminum pedestals
with computers and speakers, four
laser-disk players, four video monitors
Collection of the artist

Christine Davis
*Le dictionnaire des inquisiteurs
(tombeau)* 1994–95
installation work
dimensions variable
308 laser-etched contact lenses,
light shelf, sandblasted glass, six low-
voltage light fixtures, track, transformer,
dimmer, six flooded 35W bulbs
Collection of the artist

Monika Fleischmann
Liquid Views 1993
installation work
3 x 5 m
mini video camera, touch screen,
"Pond Installation," Videobeamer, SGI
Onyx computer with Sirius graphics
board, SGI Indigo computer, Time
Base Corrector, two speakers
Collection of the artist

Catherine Ikam
Identité III 1980
interactive installation work
dimensions variable
nine monitors, nine pedestals for
monitors, seven black-and-white
cameras, seven adapters, seven lenses
Collection of the artist

Love Story 1995
video installation
four monitors, two videodecks, two
videotapes, two speakers, and stereo
amplifier
Original music by Pierre Charvet, the
Manhattan School of Music
Collection of the artist

John Massey
Bridge at Remagen 1985
silkscreen print, edition of fifty
89.5 x 61 cm (unframed)
Courtesy of Olga Korper Gallery, Toronto

The Jack Photographs, nos. 1–35
1992–95
black-and-white photographs with
computer-processed images
each 58.4 x 61 cm (framed)
The Bailey Collection, Toronto;
courtesy of the Olga Korper Gallery,
Toronto (nos. 1–6)
Courtesy of the Olga Korper Gallery,
Toronto (nos. 7–35)

George Bures Miller

Conversation/Interrogation 1991
interactive video installation work
dimensions variable
colour television monitor, video deck,
video camera, switcher, Time Base
Corrector, infrared sensor, electronic
circuit, wooden chair, metal mounting
for television
Collection of the artist

Christian Möller

Electronic Mirror 1993
interactive installation work
mirror, LC film, two panes of glass,
ultrasonic sensor, computer, software,
power converter, profile spotlight with
dimmer pack
Collection of the artist
Support for the ultrasound system pro-
vided by Siemens AG, ASI/Geratewerk
Amberg

David Rokeby

Silicon Remembers Carbon 1993–95
interactive video installation work
5 x 4 x 6 m
two laser-disk players, Digital Time
Base Corrector, two VNS video motion
processors, two video cameras, MIDI
audio mixer, infrared motion detectors,
interactive video mixer, laser-disk con-
trollers, video projector, computer, two
stereo amplifiers, four speakers, sand,
stretched Mylar mirror
Collection of the artist

Julia Scher

Predictive Engineering 1993
interactive installation work
software, three colour surveillance
cameras, transformers, video
switchers, 3/4" videotapes, audio-
tapes, four speakers, four brackets,
two green dongles, two computers
with monitors, two computer genlocks,
two 3/4" playback decks, VHS Time
Lapse Recorder
Collection of the artist

Bill Spinhoven

I/Eye 1993
interactive installation work
55 x 50 x 50 cm
computer, camera in cylinder, pedestal
Courtesy of the Artist and MonteVideo,
Amsterdam

ABOUT THE ARTISTS

Sylvie Bélanger (Canada)

Sylvie Bélanger was born in Quebec and currently lives in Toronto and Amsterdam. She completed her Bachelor of Fine Art at Concordia University and received a Master of Fine Art from York University. Bélanger also holds a Certificate of Education from the Université du Québec, Montréal, as well as a Bachelor in Philosophie des Religions from the Université de Montréal. She teaches at the School of Visual Arts, University of Windsor, where she co-ordinates the graduate program. Her work has been exhibited widely, both nationally and internationally, at such institutions as the Oakville Art Galleries, Oakville, Ontario; Genereux Grunewald Gallery, Toronto, now the Linda Genereux Gallery; Parbleu, Antwerp, Belgium; Southern Alberta Art Gallery, Lethbridge; Centre d'art contemporain de Reuil-Malmison, France; Centre d'art contemporain St. Vincent, Herblay, France; and Galeria Oliva Arauna, Madrid, Spain. Her work was recently on view at Le Magasin in Grenoble, France.

Jim Campbell (United States)

Jim Campbell was born in Chicago and now lives in San Francisco. He received two Bachelor of Science degrees from the Massachusetts Institute of Technology in both electronic engineering and mathematics. Campbell has exhibitions scheduled for presentation at the San Francisco Museum of Modern Art, the Los Angeles Center for Photographic Studies, and the Arts Commission Gallery, San Francisco. He has shown regularly throughout the United States in such institutions as the San Francisco Museum of Modern Art; the Carpenter Center, Harvard University; the California College of Arts and Crafts, Oakland, California; and the International Center for Photography, New York. His work is included in collections at the San Francisco Museum of Modern Art; the University Art Museum at Berkeley; the Richard and Rosalyne Swig collection; and that of Don Fisher of the Gap Corporation, San Francisco.

Edmond Couchot (France)

Edmond Couchot is director of research projects and applied technology and professor at the Université Paris 8, where he runs the Arts et Technologies de l'Image program. He is interested in theoretical questions concerning the relationship between art and technology, especially graphic arts and information technologies. He has published many articles on the subject and a book titled *Images – De l'optique au numérique* (Hermès), in which he analyzes the appearance of new systems of visualization founded on interactive technology and the cultural changes that it is capable of provoking. Couchot has been interested, since 1965, in the involvement of the viewer in his *Mobiles musicaux* –illuminated cybernetic devices that react to auditory stimulation (music, voices, sounds), and through this in real-time visual interpretations in which automatism has been influenced by chance interventions. The work *Je sème à tout vent (plume et pissenlit)*, produced with the collaboration of Michel Bret and Marie-Hélène Tramus, returns to this initial interest involving all the information technologies.

Luc Courchesne (Canada)

Luc Courchesne, born in Quebec, currently lives in Montreal, where he is a professor at the Université de Montréal. Courchesne received his Bachelor's in Communications Design from the Nova Scotia College of Art and Design and a Master of Science from the Massachusetts Institute of Technology. His work has been shown extensively at international multimedia conferences and exhibitions such as *Articles 3*, Paris, 1994; SIGGRAPH, Anaheim, California, 1993; the *MuuMedia* Festival, Helsinki, Finland, 1993; The Third *International Symposium in Electronic Arts*, Sydney, Australia, 1992; and *National Design Engineering Show*, Chicago, 1992. His work has also been exhibited at such institutions as the National Gallery of Canada, Ottawa; the Musée d'art, Nice; the Ian Potter Gallery, Melbourne, Australia; and PRIM, Montreal. His installation *Family Portrait: Encounter with a Virtual Society* was on view at the Museum of Modern Art, New York, in the summer of 1994.

Christine Davis (Canada)

Christine Davis was born in Vancouver and lives in Toronto and Paris. A travelling survey of her work toured in 1994 and 1995 to the CREDAC Centre d'Art Contemporain, Paris; the Macdonald Stewart Art Centre, Guelph; the Indianapolis Museum of Modern Art, Indianapolis; the Norman Mackenzie Art Gallery, Regina; and the Winnipeg Art Gallery. Davis has participated in group exhibitions internationally, including *The Body/Le Corps*, Kunsthalle Bielefeld and Haus am Walsee, Berlin; *Prospect 93*, Frankfurter Kunstverein, Frankfurt; *March 14*, Galerie Juano Mordo, Madrid; *Eros c'est la vie*, Le Confort Moderne, Poitiers; *Das Sibyllinische Auge*, Kunstlerwerkstatten Lothringer Strasse, Munich; *Embodying Faith*, the New Museum of Contemporary Art, New York; and *Collectif Generation, Livres d'Artistes*, Victoria and Albert Museum, London, England. She is represented by the Olga Korper Gallery in Toronto. Davis is a founding member of the Public Access collective and editor of the interdisciplinary journal *PUBLIC*.

Monika Fleischmann (Germany)

Monika Fleischmann is a research media-artist and head of computer art
activities at the GMD (Gesellschaft für Mathematik und Datenverarbeitung
MBH), Sankt Augustin, Germany. She is responsible for establishing the
"Cyberstar" competition on interactive concepts (with WDR – German TV).
In 1988 she was a co-founder of Art+Com Berlin, the first of a number of
interdisciplinary research institutes in Germany that combine expertise in
media technology and in art. Fleischmann has taught art and drama work-
ing with computer graphics. Together with Christian Bohn and Wolfgang
Strauss, with whom she created her work *Liquid Views*, she received several
prizes for computer art installations (Golden Nica for Interactive Art, Unesco
Award Nomination) and she is involved in management and development of
virtual-reality systems for science, art, and education.

Catherine Ikam (France)

Catherine Ikam was trained as a lawyer, but began her career with the
French national broadcasting authority, ORTF, eventually becoming head of
the Graphic Arts department. She left in 1979 to initiate the *Video USA* series
on American video artists for another network, Antenne 2. Since 1980, she has
been known for her work in video and computer technology exploring the con-
cepts of time and space. In 1984–85, she was a research fellow at the Center
for Advanced Visual Studies at the Massachusetts Institute of Technology.
With Ted Machover, in 1985, she wrote a video opera, *Valis*, which was pro-
duced by the Musée National d'Art Moderne and the Institut de Recherche
et de Coordination Accoustiques et Musicales for the tenth anniversary of the
Centre Georges Pompidou. Ikam has since 1991 been principally engaged in
the creation of virtual environments, working with Louis-François Fléri, the
Mac Guff Ligne studio, Ircam, and Silicon Graphics. Their 1991 environment
L'Autre received a prize at *Ars Electronica*, Linz, Austria. Her work has been
exhibited extensively at such institutions as Cité des Nouvelles Technologies,
Montreal (1991); Kunstverein, Bonn (1992); the Tate Gallery, Liverpool (1993);
École National des Beaux-Arts, Paris (1993); Musée d'Art Contemporain de
Bologne (1994); and the Ontario Science Centre, Toronto (1994). She lives
in Paris.

John Massey (Canada)

John Massey was born in Toronto, where he lives. Solo exhibitions of his work have been shown both nationally and internationally at various institutions, including the Olga Korper Gallery, Toronto (1992); the Art Gallery of Ontario, Toronto (1991); the Canadian Cultural Centre, Paris (1990); the Galerie Chantal Boulanger, Montreal (1989); Ruimte Morguen, Antwerp (1988); and the Mattress Factory, Pittsburgh (1988). Massey has participated in group exhibitions at the Proctor Art Center, Bard College, Annandale-on-Hudson, New York.

George Bures Miller (Canada)

George Bures Miller lives in Lethbridge, Alberta. Miller graduated from the Ontario College of Art in Toronto in 1986 with a degree in Photo/Electronic Arts. He has had solo exhibitions at various institutions throughout Canada, including Galerie Clark, Montreal (1994); La Chambre Blanche, Quebec City (1992); Neutral Ground, Regina (1992); Artcite Inc., Windsor (1991); Latitude 53 Gallery, Edmonton (1989); and Ed Video Media Arts Centre Inc., Guelph (1988). In 1995, he will be showing at the Southern Alberta Art Gallery, Lethbridge, and at A.K.A. Artists' Centre, Saskatoon. Miller's works have also appeared in group exhibitions in the Project Artaud at the Southern Exposure Gallery, San Francisco (1993); the Edmonton Art Gallery (1991 and 1990); the Walter Philips Gallery, Banff (1990); and Gallery 76, Toronto (1988). In 1991, he participated in the Bioapparatus Session, art studio program, Banff Centre for the Arts.

Christian Möller (Germany)

Christian Möller was born in Frankfurt, Germany, where he studied architecture and received a post-graduate scholarship studying under Gustav Peichl at the Vienna Academy of Applied Arts. Since 1990, Möller has been head of his own architectural studio, which has a special laboratory for electronic media and software development, in Frankfurt. He has taught classes on Virtual Architecture in the Frankfurt Städelschule's architecture department and is currently a guest artist at the Institute for New Media. His work has been in various exhibitions, including *Space Balance*, *Ars Electronica* 92, Linz, Austria; *Kinetic Light Sculpture*, Zeilgaleria, Frankfurt; *Surfaces of Variable Visibility*, Stadtpark Gallery, Krems, Austria; *Interactive Architecture*, Aedes Gallery, Berlin; and *Audio Pendulums*, the International Symposium of Electronic Art, Helsinki.

David Rokeby (Canada)

David Rokeby was born in Tillsonburg, Ontario, and now lives in Toronto. He graduated with honours in Experimental Art from the Ontario College of Art. He participates frequently in symposia on new art technologies and in international festivals where his work is exhibited. In 1991, Rokeby was an artist-in-residence for the Bioapparatus Session at Banff. Best known for his interactive sound systems, which have been installed in various international institutions, he has also had work shown at *Ars Electronica*, the *MuuMedia* Festival, SIGGRAPH, the International Symposium on Electronic Art, the Venice *Biennale*, and other international festivals.

Julia Scher (United States)

Julia Scher received her Bachelor's degree in Studio Arts from the University of California, Los Angeles, in 1975 and her Master of Fine Arts in Studio Art from the University of Minnesota, Minneapolis, in 1984. Scher has had individual exhibitions at several international institutions, including the Andrea Rosen Gallery, New York; Kölnischer Kunstverein, Cologne, Germany; Galerie Metropol, Vienna; and the Wexner Center for the Arts, Columbus, Ohio. She has lectured widely at such institutions as Princeton University, New York University, the Cooper Union, the Institut für Gegenwartkunst, Vienna, and the San Francisco Art Institute. Scher has received grants from the NEW Inter Arts (1992), Art Matters Inc. (1993 and 1989), and Artist Space (1988). She lives in New York, where she runs her own company, Safe and Secure Productions.

Bill Spinhoven (Holland)

Bill Spinhoven was born in Velsen, the Netherlands, and completed his studies at the Technical University on Twente and the Academy of Fine Arts, AKI, Enschede, the Netherlands. His video-based work has been exhibited around the world from Taiwan to Japan, Holland, Spain, the United States, Germany, Hungary, and Italy. Spinhoven is represented by MonteVideo Time-Based Arts in Amsterdam.

ABOUT THE AUTHORS

Louise Dompierre

Louise Dompierre is Associate Director and Chief Curator of The Power Plant. Since she joined the Gallery in 1985, she has been curator and co-curator of numerous exhibitions, including *Toronto: A Play of History (Jeu d'histoire); Prent/Cronenberg: Crimes Against Nature; Robert Fones: From Material Life into Art History; In Between and Beyond: From Germany, Ann Hamilton: A Round; Michael Snow: Embodied Vision; Yasumasa Morimura; Naked State; and Spring Hurlbut: La Somnolence*. She has lectured and published widely as well as collaborated in various curatorial capacities with a number of art institutions abroad, including Le Magasin, Grenoble (1994), the Contemporary Arts Museum, Houston (1993), the Wurttembergischer Kunstverein, Stuttgart (1992), the Musea da Gravura, Brazil (1992), and CREDAC, Paris (1990).

Michael Heim

Michael Heim is a philosophy professor who teaches graduate seminars in Virtual Reality at the University of Southern California School of Cinema-Television and at the Art Center for Design in Pasadena. He teaches as well in the Science and Technology Program at the California State University Long Beach Extension, including Virtual Reality for Engineers and Internet Applications. Heim also teaches Tai Chi and directs Tai Chi Redondo Beach. He can be reached on the Internet at: mheim@earthlink.net or mheim@mizar.usc.edu.

Derrick de Kerckhove

Derrick de Kerckhove is Director of the McLuhan Program in Culture and Technology and professor in the department of French at the University of Toronto. He received his Ph.D. in French Language and Literature from the University of Toronto in 1975 and a Doctorat du 3e cycle in Sociology of Art from the University of Tours, France, in 1979. He was an associate of the Centre for Culture and Technology from 1972 to 1980 and worked with Marshall McLuhan for more than ten years as translator, assistant, and co-author. His most recent book, *Brainframes: Technology, Mind and Business* (Utrecht: Bosch & Keuning, 1991) addresses the differences in the effects of television, computers, and hypermedia on corporate culture, business practices, and markets. Besides his scientific interests in communication, de Kerckhove is interested in artworks that bring together art, engineering, and emerging communication technologies. Another book, *Les Transintéractifs* (Paris, Éditions SNVB – La Villette) is due to be published soon.

Robert R. Riley

Robert R. Riley was named the first curator of Media Arts for the San Francisco Museum of Modern Art in 1988. He is responsible for the organization and presentation of exhibitions of artists working in video, multimedia installation formats, and time-based, mechanically dependent works of art. He initiates new productions, commissions video and performance artworks, and acquires installations and works in video formats for the museum's permanent collection. Prior to his appointment to SFMOMA, Riley was Curator of Video and Performance Art at the Institute of Contemporary Art in Boston. During his tenure at ICA, he organized a wide range of videotape exhibitions, media installations, and performances. He is the author of numerous articles and publications on video and performance art and has taught courses in contemporary media at the San Francisco Art Institute, the Massachusetts College of Art, and the School of the Museum of Fine Arts, Boston.

Allucquère Rosanne Stone

Allucquère Rosanne Stone is Assistant Professor in the department of Radio-TV-Film at the University of Texas at Austin, where she studies issues related to interface, interaction, and desire. She is Director of the Advanced Communication Technologies Laboratory. Previously she was a visiting lecturer in the departments of Communication and Sociology at the University of California San Diego, where she taught film, linguistics, gender, cultural studies, and feminist theory. She has conducted research on the neurological basis of vision and hearing for National Institutes of Health; was a member of the Bell Telephone Laboratories Special Systems Exploratory Development Group; has been a consultant, computer programmer, technical writer, and engineering manager in Silicon Valley; and worked with Jimi Hendrix in music recording. She has been published extensively in a variety of academic journals and books, and contributes frequently to international conferences on cyberspace. Her book *The War of Desire and Technology at the Close of the Mechanical Age* will be published by MIT Press in May 1995. She is editing the first academic reader on transgender theory, completing a science fiction novel, and working on a study of vampirism and carnival. She is currently touring a one-person "theoryperformance" on cyberspace and the transhuman.

GALLERY
ACKNOWLEDGEMENTS

Funding

The Power Plant—*Contemporary Art Gallery at Harbourfront Centre* is a registered Canadian charitable organization supported by membership, private donations, sponsorship, and all levels of government. The Power Plant gratefully acknowledges the assistance provided by The Canada Council, the Ontario Arts Council, the Ontario Ministry of Culture, Tourism and Recreation, Municipality of Metropolitan Toronto, the Toronto Arts Council, and Harbourfront Centre.

The Power Plant extends its appreciation to the following for the financial support of this exhibition: The Canada Council through the Exhibition Assistance Programme; Government of Ontario through the Ministry of Culture, Tourism and Recreation; Goethe-Institut Toronto; AFAA, Association Française d'Action Artistique, Ministère des Affaires Étrangères, Paris; Ministry of Foreign Affairs (Bonn), Germany; Consulat Général de France, Service Culturel, Scientifique et de Coopération.

Press/Enter is generously sponsored by AT&T Canada **≋AT&T** Canada

The Power Plant would like to extend its appreciation to the following for assisting with the equipment needs of the exhibition:

Art Gallery of Ontario (Greg Baszun, Media Technician)

Oakville Galleries (Rod Demerling, Installation Officer/Registrar)

Pioneer Electronics Canada, Inc. (Martes Farrugia, Manager, Industrial Products Division)

San Francisco Museum of Modern Art (Robert Riley, Curator of Media Arts and Justin Graham, Media Arts Program Assistant)

University of Western Ontario (Sheila Butler, Acting Head, Department of Visual Arts, and Wyn Geleynse, Resource Director)

The Power Plant Staff

Catalogue
Acknowledgements

Editing: Alison Reid

Design: Adams + Associates

Printing: Somerset Graphics